BRUCE

NAUMAN

MAKE ME

TATE LIVERPOOL

Edited by Laurence Sillars

THINK ME

First published 2006 by order of the Tate Trustees
by Tate Liverpool, Albert Dock, Liverpool L3 4BB

in association with
Tate Publishing, a division of Tate Enterprises Ltd, Millbank, London SW1P 4RG www.tate.org.uk/publishing
on the occasion of the exhibition

Bruce Nauman: Make Me Think Me
Tate Liverpool, 19 May – 28 August 2006
MADRE, Naples, 14 October 2006 –8 January 2007
The exhibition at Tate Liverpool is supported by Tate Liverpool Members

British Library Cataloguing in Publication Data
A catalogue record for this book is available from the British Library

ISBN-13: 978-185437-708-6
ISBN-10: 1-85437-708-1

Distributed in the United States and Canada by Harry N. Abrams, Inc., New York

Library of Congress Cataloging in Publication Data
Library of Congress Control Number: 2006926369

Designed by Piccia Neri www.piccianeri.com
Printed by Print Wright, Ipswich

Front cover: *Setting a Good Corner (Allegory and Metaphor)* 1999
Back cover: *Double Poke in the Eye II* 1985

CONTENTS

FOREWORD

Christoph Grunenberg
Director

To present an exhibition of an artist so enormously influential as Bruce Nauman is both a responsibility and a rewarding challenge. Despite a consistency of preoccupation and analytical approach, the proliferation of media and forms employed by the artist has rendered the possibility of a retrospective exhibition in any traditional sense unfeasible. As such, despite including works from 1966 to 2005, *Bruce Nauman: Make Me Think Me* represents a concentrated examination of the artist's work focussing on his relentless questioning of the fundamentals of the human condition. Divided into two parts, the first explores the artist's use of language which is juxtaposed in the second with his examination of physical and mental activity, be it his own or that of the audience.

An exhibition of this scale and ambition would not have been possible without the support of many individuals and institutions. Our thanks must, above all, go to the artist who has been most generous in his support of this project. We are also indebted to those who have most generously and graciously lent to the exhibition and would like to thank them for their cooperation. Despite the fragility of many of the works included, we have been met with nothing but support by lenders despite, in some cases, the need even to remove objects from their own displays. We would particularly like to thank Anna and Josef Froehlich, with whom Tate enjoys a long-standing relationship. Without their support, this exhibition would not have been possible.

We would also like to thank the following individuals who facilitated the exhibition in so many ways: Angela Westwater and all her staff at Sperone Westwater Gallery, New York; Anita Balogh, Froehlich Foundation, Stuttgart; Donald Young and Tiffany Stover, Donald Young Gallery, Chicago; Vicki Gambill, The Broad Art Foundation; Curtis Harvey, Dia:Beacon and Patrick Peternader, Friedrich Christian Flick Collection. Michael Short of Sperone Westwater Gallery and Juliet Myers, the artist's assistant, have been luminous fountains of knowledge and support for which we are sincerely grateful. We are most pleased that the exhibition will be shown at MADRE, Museo d'Arte Contemporanea Donnaregina, Naples, following the presentation in Liverpool. We would like to thank Eduardo Cicelyn, Director, and Mario Codognato, Chief Curator, for the fruitful collaboration.

The exhibition benefits greatly, and will be outlived by, this catalogue. I am extremely grateful to Lynne Cooke, Anna Dezeuze, and Johanna Drucker for contributing such valuable and insightful essays. I would also like to thank Jemima Pyne, Larissa Kolstein, Ian Malone and Helen Tookey for producing the publication and Piccia Neri for her sensitive design.

As ever, the dedication and enthusiasm of our colleagues within Tate has been invaluable. Sir Nicholas Serota's support was critical in making this exhibition possible at Tate Liverpool. I would like to thank in particular Laurence Sillars who devised and curated the exhibition. His enthusiasm and devotion to the project has resulted in a spectacular exhibition and lasting publication. He was reliably and meticulously supported by Darren Pih. The shipping and installation arrangements were diligently cared for by Wendy Lothian, Ken Simons, Barry Bentley, Roger Sinek and Stephen Gray. We would like to thank Tate conservators Jo Gracey, Kate Jennings, Pip Laurenson and Neil Wressell for their wealth of expertise and Jean Tormey and Maria Percival for their work on education and interpretation. The exhibition has been made possible in part by Tate Liverpool Members and we would like to thank them for their continued support.

Tate has enjoyed a long-standing relationship with Bruce Nauman, from acquiring its first major work by the artist, *Corridor with Mirror and White Lights*, as early as 1973 to, most recently in 2005, realising *Raw Materials*, the fifth Tate Modern Turbine Hall commission in the Unilever Series. In 2006, forty years after the artist's first solo exhibition, held at the Nicholas Wilder Gallery, Los Angeles, I am delighted that Tate Liverpool is presenting an exhibition that will allow audiences to see such a comprehensive and elucidatory body of work from one of the most important artists of our time.

BRUCE NAUMAN: KEEPING BUSY

Laurence Sillars

My work comes out of being frustrated about the human condition.

And about how people refuse to understand other people.[1]

In 1970, the Leo Castelli Gallery in New York published a portfolio of photographs made by Bruce Nauman between 1966 and 1967.[2] Collectively, the images of *Eleven Color Photographs* represent the beginnings of the two interrelated routes through

Following page:
Coffee Thrown Away Because It Was Too Cold 1966-7/70

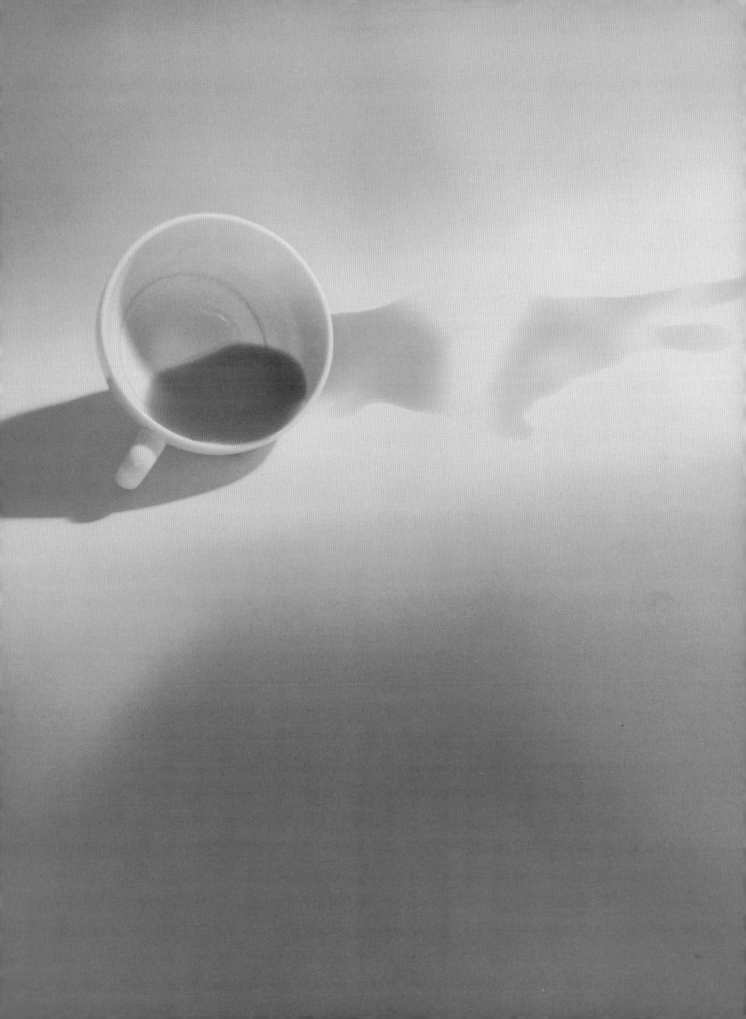

BRUCE NAUMAN: KEEPING BUSY

which Nauman has systematically examined the nature of human activity over the last forty years: language and physical behaviour. In 1966, just graduated, Nauman found himself alone in the studio with little money for materials yet significant time on his hands: 'I paced around a lot, so I tried to figure out a way of making that function as the work. I drank a lot of coffee, so those photographs of coffee thrown away…'[3] The mundane, daily activities Nauman incorporated into these photographs, and subsequent works, became symbolic of his questioning not only of the role of the artist in society but of the human condition. Although his investigations of word and behaviour frequently collide, it is specifically his use of language, something that, as Mikhail Bakhtin acknowledged, is implicated within 'all the diverse areas of human activity', that needs initial consideration.[4]

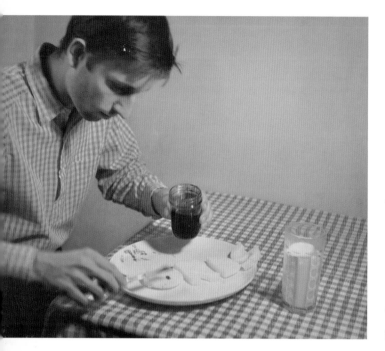

Eating My Words 1966-7/70

Eleven Color Photographs visually provides a quasi-document of the artist in his studio. Yet the individual titles are as significant as the images to which they belong: *Bound to Fail*, *Coffee Spilled Because the Cup Was Too Hot*, *Coffee Thrown Away Because It Was Too Cold*, *Drill Team*, *Eating My Words*, *Feet of Clay*, *Finger Touch No. 1*, *Self-Portrait as a Fountain*, *Untitled (Potholder)*, and *Waxing Hot*. Offered here are the textual instructions for physically performed acts, and linguistic puns that provide the basis for their visual manifestations, along with the occasional nod to art history. Rather than being subservient to them, the titles dictate the images, defining what Janet Kraynak has described as 'a "performance" structure'.[5] Although interconnected, the words corrode and undermine the structural relationship between title and object, sign and signified and, crucially, begin to test the use value and functional stabilities of language.

It is the 'functional edges' of language that are of greatest interest to Nauman:

> The place where it communicates best and most easily is also the place where language is the least interesting and emotionally involving – such as the functional way we understand the word 'sing' or the sentence 'Pick up the pencil'. When these functional edges are explored, however, other areas of your mind make you aware of language potential. I think the point where language starts to break down as a useful tool for communication is the edge where poetry or art occurs.[6]

Nauman's education and early influences reveal much about his approach. During his undergraduate degree at the University of Wisconsin, he studied mathematics and physics as well as art: although he didn't become a mathematician, 'there was a certain thinking process which was very similar and which carried over into art. This investigative activity is necessary.'[7] Language, then, becomes the subject of a scientific experiment, analytically tested to gain a better understanding of its use and usefulness. Alongside literature – the linguistic tricks of Robbe-Grillet and Nabokov especially – Nauman studied the writings of Wittgenstein. He was also a keen musician, playing the guitar and informally studying theory and composition. His enthusiasm for the work of Arnold Schoenberg is particularly interesting. Schoenberg replaced tonal techniques with a serial structure in which all twelve semitones are of equal value. His serial compositions were each based on a 'tone row' of this kind, played in its original order, its inversion, retrograde or retrograde inversion. This rejection of traditional forms and the use of patterns, often repeated, is akin to the mathematical processes often employed by Nauman in his revisionist approach to language and sentence structure. As Schoenberg's music rejects the logic of tonal progression and resolution, so Nauman's word-pieces reject the logic of referential language.

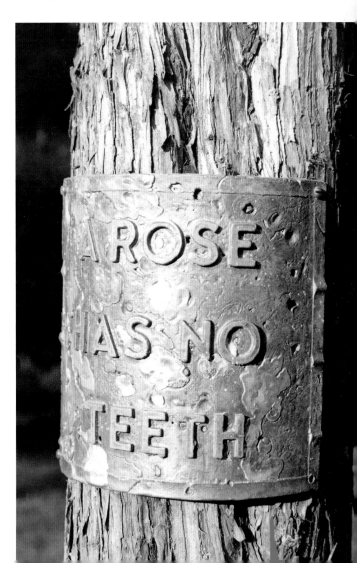

A Rose Has No Teeth 1966

Nauman approaches language with naivety, as if starting from scratch, a working method borrowed from his tutor William T. Wiley who encouraged 'seeing with the dumb eye'.[8] He uses multiple forms of word-play – puns, palindromes, anagrams, repetition – to manipulate language to the point at which meanings shift or multiply and syntax no longer functions. By doing so, he provokes a greater understanding of the world and its relationships. Initially present only in titles, this linguistic disintegration soon constituted the actual works, the first being a lead plaque bearing the legend 'A ROSE HAS NO TEETH' in 1966.[9] Two years later, in *First Poem Piece*, Nauman transposed the words of the phrase 'you may not want to be here' onto the intersections of a grid engraved on a steel slab. Reading from top to bottom, left to right, the phrase is transformed over eighteen lines by omitting a combination of words and, in the final six lines, by replacing 'here' with 'hear': 'You May Not Want To Be Here', 'You May Not Want To Be', 'You May Not Be',

'You May Not Hear' and so on. Nauman redirects the mathematical logic and structure of the grid, typically used to control and order information, to methodically undermine the words' capacity to convey finite meaning, individually or collectively.

Many of Nauman's word-games have been performed in neon, a material well suited to the examination of language. While attached to an otherwise self-sufficient object – a plaque or steel slab bearing the hallmarks of Minimalist sculpture – language retains a functional edge. Visually seductive (it is still a prevalent advertising medium), neon emphasises the formal and compositional qualities of language, moving it beyond a referential framework to one free of semiotic relationship. The word 'substitute' is

First Poem Piece 1968

problematised in *Suite Substitute* 1968, one of the artist's earliest neon pieces. The word 'SUITE' is superimposed over the same letters in the word 'SUBSTITUTE'. The pink letters of the first word flash alternately with the green of the second, revealing the construction of each by allusion to the other, exposing language as a system referring only to itself. The work accentuates the alternative possibilities of each word by removing them from functional context: 'suite' as noun or collective noun (we also 'hear' the word 'sweet') and 'substitute' as noun or verb.[10] Seeing the switch between the two words taking place, the viewer begins to turn the word into an anagram – something Nauman has also performed in neon, as in *La Brea/Art Tips/Rat Spit/Tar Pits* 1972.

The technical possibilities of neon were fully exploited by Nauman in order to deconstruct language further. *Raw War* 1970 consists of the letters W A R programmed to illuminate in sequence: 'R' flashes on and off, then 'A' comes on and remains on until the 'W' and 'R' join it to make the word. The sequence repeats endlessly. Animating a simple palindrome, the individual letters continually repurpose themselves by refusing to belong to either of the words 'war' or 'raw'. Again, a mathematical logic is applied through the neon's programming to displace the letters' finite role. The sequencing of such works presents the audience with lists of information that continually update and undermine themselves, as in the multi-layered text *Human Nature/Knows Doesn't Know* 1983/86. Here, four superimposed phrases, each with substitute verbs at both beginning and end, flash alternately so as to exhaust every possible combination. Such simultaneous combination of multiple, and often contradictory, information in and through text is a deliberate ploy further to remove fixed function or meaning. Ultimately leading to a re-evaluation of language as our fundamental

tool for interaction, such works force us, as Robert Storr has argued, 'to confront the world as if our habitual means of contact with it needed to be re-learned'.[11]

The repetitive scripts for the video installations *Good Boy Bad Boy* 1985 and *World Peace (Received)* 1994 come from the same lists of information, typically relating to the human condition, as many of the neons. The two actors of *Good Boy Bad Boy* recite 25 stanzas,

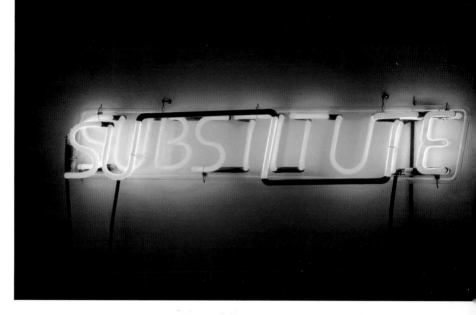

Suite Substitute 1968

each including one noun in four lines that is progressively altered in meaning through alternative verbs and pronouns: 'I'm having fun / You're having fun / We're having fun / This is fun' and so on. The meaning of the words oscillates not only through changing grammatical structure but through variations in tonal and physical delivery. All 25 lines are repeated five times, each with a different performative thrust, starting flat and becoming increasingly animated. Speaking at different speeds, the voices slip out of synchronisation and so continually relate to each other in new ways. In *World Peace (Received)* a cast of five, each in a different setting (one at a lectern, one smoking), are shown on individual monitors. As in *Good Boy Bad Boy*, the actors repeat stanzas based on a variation of verbs, this time those that describe the basic structure of communication: 'talk' and 'listen'. Again, their meanings are altered through the use of alternative pronouns. One speaker also communicates by sign language; signification remains constant yet the medium becomes visual.

Good Boy Bad Boy 1985

The monitors of *Good Boy Bad Boy* are at head height and to view *World Peace (Received)* we are invited to sit at the centre of the room so that the speakers surround us. Yet these are not the only methods through which the audience becomes implicated. According to Bakhtin's notion of the 'utterance', a spoken word immediately becomes part of a dialogic relationship and its meaning is determined not at the moment it is spoken but at the point at which it is received.[12] Furthermore, like many of Nauman's 'written' words, many of the

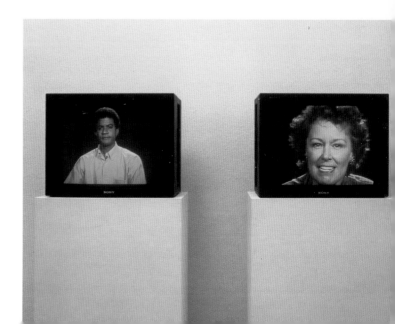

lines address us directly, almost as commands: the 'You'll talk, I'll listen…They'll talk, You'll listen' of *World Peace (Received)*, for example. Nauman's language-based works frequently have the air of a command which is then subtly displaced: *Run from Fear, Fun from Rear* 1972 or *Make Me Think Me* 1994.

This aspect of the relation between language and control began to be a part of Nauman's work as early as 1968. In *Get Out of My Mind, Get Out of This Room*, a work that exists purely as sound, he recorded himself repeating the title words in different ways: 'I changed my voice and distorted it, I yelled it and growled it and grunted it.'[13] The work

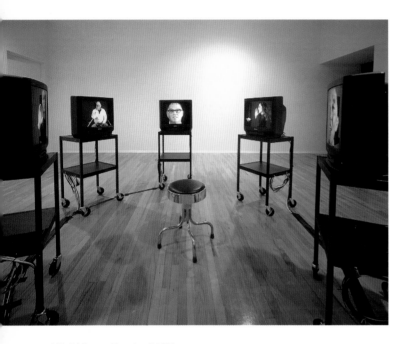

World Peace (Received) 1996

is frightening to experience, and unexpected. Installed alone in a room with hidden speakers, it immediately instructs us to leave, transgressing the coding of the public space in which it is exhibited. In 1973 Nauman filmed two actors he had instructed to lie on a concrete floor in a television studio and used language to direct a psychological exercise. The resulting footage in the videos of *Elke Allowing the Floor to Rise Up over Her, Face Up* and *Tony Sinking into the Floor, Face Up and Face Down* is alarming. Several minutes into the exercise, Tony sat bolt upright and gasped for air: 'I just tried to do it too fast, and I was afraid I couldn't get out.'[14] Elke, having a similar experience, 'broke out into an incredible sweat and couldn't breathe'.[15] Focusing upon the words of an instruction and the sensation of the body against the floor, the activity became trance-like. The same is required of the audience in *Body Pressure* 1974, a wall-mounted poster that instructs us to 'Press as much of the front surface of your body (palms in or out, left or right cheek) against the wall as possible' and to '[c]oncentrate on tension in the muscles, pain where bones meet, fleshy deformations'. The final line reveals: 'This may become a very erotic exercise.'[16] Language here initiates a type of behavioural science in an experiment that stimulates physical and mental behaviour, promoting an awareness of body and mind. The texts become a form of Gestalt therapy, something Nauman studied in 1967 by reading the work of Frederick Perls. Perls provides the reader with 'Techniques of Awareness' to facilitate self-understanding and personality growth. One such experiment begins 'Concentrate on your "body" sensation as a whole.'[17] Here, the decontextualisation apparent in Nauman's word-pieces is applied to

an activity that stands for the whole discipline of therapy, marking the shift from language to human activity, a key element of his work.

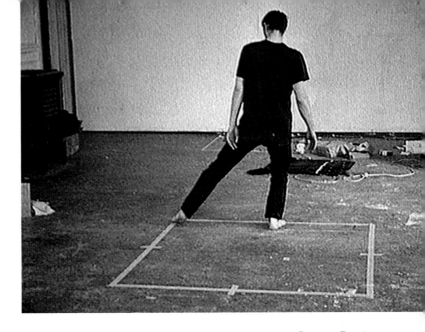

This shift may reflect Nauman's growing dissatisfaction with eliciting specific behavioural responses through language-based works. Despite increasingly specific instructions, the written information ultimately, he felt, remained 'vague and open'.[18] His own experiments with language have certainly revealed this tendency. 'I think it is almost like reading Robbe-Grillet: you come to a

Dance or Exercise on the Perimeter of a Square (Square Dance) 1967-8

point where he has repeated what he has said earlier, but it means something altogether different, because even though he has changed only two words, they have changed the whole meaning of the thing he is talking about.'[19] Acknowledging the limitations of language, Nauman has used physical environments to control and examine behaviour.

Shortly after staging the actions in *Eleven Color Photographs*, Nauman began a series of films and videos recording his performance of simple, repetitive activities in the studio, each responding to a specific 'problem'. In *Dance or Exercise on the Perimeter of a Square* 1967–68, he methodically navigates a square made on the floor with masking tape.[20] Using halfway points marked on each side to order his movements, he steps from one side to the next following the beat of a metronome. In *Slow Angle Walk (Beckett Walk)* 1968 he again moves following a set, mathematical pattern. With his body bent at ninety degrees (and the camera at the same angle), he takes each step by lifting one leg at a right angle to the body, pivoting and landing with a forceful thud. The opposite leg follows before the entire action is repeated. Nauman progresses slowly around the studio in this awkward manner, sometimes disappearing from view. As with many of the 'studio films' made between 1967 and 1968, Nauman repeats the movement for nearly one hour; it thus becomes as much a mental as a physical exercise. Like his examinations of language – a grid to order words, the sequenced programming of a neon – his actions are always performed within set parameters: space, a particular movement or pose, or a prop or pattern. Challenging to perform (he practised at length before recording), the threat of failure is ever present, provoking in the viewer an empathy or, as Nauman has described it, a 'body response'.[21]

Rarely showing his full body or face in the videos, Nauman removes all autobiographical association. Used purely as an object, his figure assumes universal

significance, referring to 'the things that happen to a person in various situations – to most people rather than just to me or one particular person'.[22] Infinitely looped, the videos become metaphors for the rituals and struggles of daily human existence and, as such, owe much to the plays and stories of Samuel Beckett, which Nauman first read in 1966.[23] Nauman shares with Beckett an obsession with the human condition: both use

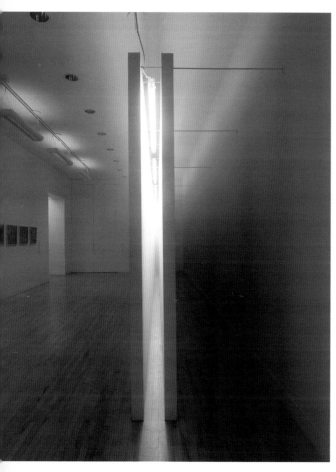

*Corridor with Mirror
and White Lights* 1971

repetitive, non-productive and often solitary physical activity to reveal the lot of humankind – its modes of behaviour, frustrations, abilities and frailty. Like the figure in the studio, some of Beckett's characters never stop performing – Vladimir and Estragon will never leave the stage of *Waiting for Godot* – and become symbols of humankind's continuing, obsessive struggle.[24] It is interesting to acknowledge again the relationship between written language and physical behaviour in Nauman's works: the walk of *Slow Angle Walk (Beckett Walk)* almost uses the description of Molloy's painful walk with a stiff leg and crutch as an instruction. That the audience witnesses the physical activity is crucial to an understanding of the body under physical and mental duress: 'An awareness of yourself comes from a certain amount of activity, and you can't get it from just thinking about yourself.'[25]

It may be a further reflection of Nauman's logical processes that he soon became concerned with the movements of his audience. Initially used as a prop to define his own movement, the corridor in *Walk with Contrapposto* 1968 was displayed in its own right the following year, becoming his first construction to direct the behaviour of the audience. Many other environments followed, exposing the audience to increasing anxiety and vulnerability. Most complex in construction and effect is *Corridor Installation (Nick Wilder Installation)* 1970, consisting of an inaccessible room and six corridors, three of which may be entered. Two monitors are stacked at the end of the second corridor, the higher displaying footage of the empty space, the lower relaying a live image from a camera at the same viewpoint. As we approach, we expect to see our own image – our only means of ordering the environment. However, such is the positioning of the camera that we appear only after progressing some way into the space. As the camera is mounted high behind us, the reverse of our expectation occurs: the closer we get, the

further our image recedes. After encountering a monitor relaying footage from within the inaccessible room, our final experience comes as we turn into the final corridor and see a fleeting image of our body, taken from behind, appearing to fall.[26] The information from the monitors contradicts that of actual experience. Visual and kinaesthetic information collide: the irreconcilable dissonance of these qualities produces an unsettling, isolating response in the onlooker. *Double Steel Cage Piece* 1974 takes this a stage further, facilitating a collective behavioural experience. The audience enters the corridor formed between two mesh cages and attempts to enter the inner one. Just as the room of the corridor installation may be seen but not entered, so our entrance to the central cage is denied. Like Beckett's Hamm, who needs to find the exact centre of the stage for comfort, our attempt and failure to reach the inner cage is a disturbingly public one.

To enter these works is to become the performer. It is our reactions to them, both in thought and action, that determine meaning, both self-reflexively and to the absent viewer. We become the actor, yet at no point the author. Such are the spatial limitations that we never gain control: '[w]hatever ways you could use it were so limited that people were bound to have more or less the same experiences I had'.[27] As with Nauman's work with language, the variables are controlled and the experience is one of limitation in which we can only make simple responses within a highly specific set of parameters – the grid of *First Poem Piece* becomes the cage. Again, conflicting information is present throughout such structures: it is our inability to resolve these dichotomies – public and private, invitation and rejection, real and artifice – that creates the tension and dictates our reactions. Exposing the behavioural patterns of life, we become like rats in a cage, interrogated by some invisible authority.

Shifts in media and approach have been regular occurrences throughout Nauman's career, part of his continual re-evaluation of his working method. In the late 1980s, for the first time in over two decades, he returned to casting. Rather than changing his practice, however, Nauman was methodically finding new ways to investigate long-standing preoccupations. He began using taxidermists' moulds for a number of works, sometimes casting them in aluminium. *Untitled (Two Wolves, Two Deer)* 1989 uses four such moulds in their raw state, almost as ready-mades. The familiar animal forms hanging playfully from the ceiling like an over-sized mobile have, however, been

Untitled (Two Wolves, Two Deer) 1989

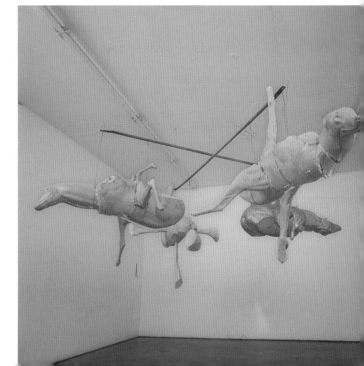

BRUCE NAUMAN: KEEPING BUSY

in their raw state, almost as ready-mades. The familiar animal forms hanging playfully from the ceiling like an over-sized mobile have, however, been radically altered. Hybrids have been created by merging different animal moulds, with heads and limbs rearranged in rejection of any anatomical logic. Displacing body parts just as he would words in a sentence, Nauman creates gruesome animals which resemble the results of some horrific experiment, a quality only enhanced by genetic tampering and the advent of cloning. As in the corridors, it is our relationship with and reaction to the sculpture that expose meaning. Because the sculptures are hung at head height, we are immediately implicated and are forced to confront our own moral behaviour and humankind's treatment of nature.

At this time Nauman also began to cast human heads. Always severed at the neck, the resultant forms are as emblematic as his figure endlessly performing in the studio. Retaining

*Three Heads Fountain
(Juliet, Andrew, Rinde) 2005*

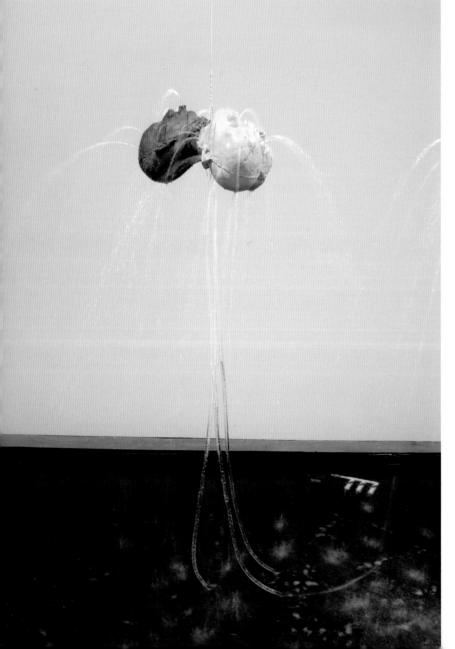

evidence of the working process has always been important to Nauman, a means to reveal and question the nature of making art, yet such evidence has a wider implication here. During the casting process, the sitters breathe through a tube – the 'plug' mentioned in several titles (*Rinde Head/Andrew (Plug to Nose) on Wax Base* 1989, for example), and left visible in several works. Nauman extends this idea to perhaps its logical conclusion in one of his most recent works, *Three Heads Fountain (Juliet, Andrew, Rinde)* 2005. The heads hang together by a single wire from the ceiling, suspended above a large basin. Water is pumped into the back of each head like an intravenous drip before being sprayed through punctures in the face. Although a violation, it is as if the water gives life. Intermittently, the pumps are switched off, the water slowly drips out of the heads and the sound of splashing that overwhelmed the gallery is silenced. As so often in Nauman's work, the sequence endlessly repeats, turning

the fountain into an emblem for the cycle of life. The animals and heads become semiotic constructs that, replacing language or physical behaviour, make some of his most powerful references yet to the state of being human.

Nauman once said of Wittgenstein that he 'would follow an idea until he could say either that it worked or that life doesn't work this way and we would have to start over. He would not throw away the failed argument, but would include it in his book.'[28] Nauman's relentless examination of all that defines the human constitutes a continuing series of experiments of much the same sort. Indeed his entire working career may be seen as the fulfilment of one of the most basic human needs. When asked in an interview in 1971 who his art was for, Nauman simply replied: 'To keep me busy.'[29]

1 Bruce Nauman in Joan Simon, 'Breaking the Silence', in Janet Kraynak (ed.), *Please Pay Attention Please: Bruce Nauman's Words: Writings and Interviews*, Cambridge, MA, and London, MIT Press, 2003, p. 332. Kraynak's invaluable publication includes fourteen of the artist's major interviews from 1965 to 2001, many of which have been drawn upon for this essay.
2 The photographs were taken by Jack Fulton.
3 Nauman in Michael De Angelus, 'Bruce Nauman Interviewed', 1980, in Kraynak (ed.), *Please Pay Attention Please*, p. 230.
4 Mikhail Mikhailovich Bakhtin, 'The Problem of Speech Genres', in *Speech Genres and Other Late Essays*, ed. Caryl Emerson and Michael Holquist, trans. Vern W. McGee, Austin, TX, University of Texas Press, 1986, p. 60.
5 Janet Kraynak, 'Bruce Nauman's Words', in Kraynak (ed.), *Please Pay Attention Please*, p. 10.
6 Nauman in Christopher Cordes, 'Talking with Bruce Nauman, an Interview', 1989, in Kraynak (ed.), *Please Pay Attention Please*, p. 354.
7 Nauman in Ian Wallace and Russell Keziere, 'Bruce Nauman Interviewed', *Vanguard* (Canada), No. 1, Feb. 1979, p. 16.
8 William T. Wiley in Coosje van Bruggen, *Bruce Nauman*, New York, Rizzoli, 1988, p. 107.
9 *A Rose Has No Teeth (Lead Tree Plaque)* 1966. The title phrase is taken from Wittgenstein's *Philosophical Investigations*.
10 Nauman made a neon *Sweet, Suite, Substitute* the same year.
11 Robert Storr, 'Beyond Words', in *Bruce Nauman*, catalogue raisonné, Minneapolis, Walker Art Center, 1994, p. 62.
12 Kraynak formulates this argument in the introduction to *Please Pay Attention Please*. See also Bakhtin's 'The Problem of Speech Genres'.
13 Nauman in Simon, 'Breaking the Silence', pp. 334–5.
14 Tony quoted by Nauman in Jan Butterfield, 'Bruce Nauman: The Center of Yourself', 1975, in Kraynak (ed.), *Please Pay Attention Please*, p. 177.
15 Ibid.
16 The visual and compositional qualities of the text are still highly considered through the layout, typeface and the pink paper on which it is printed. Although the language is functional, it retains an object-like presence.
17 Frederick Perls, Ralph Hefferline and Paul Goodman, *Gestalt Therapy: Excitement and Growth in the Human Personality*, London, Souvenir Press, 2003 (originally New York, Julian Press, 1951), p. 86.
18 Nauman in Butterfield, 'Bruce Nauman: The Center of Yourself', p. 181.
19 Ibid.
20 Unlike Nauman's videos from 1967–68 which last approximately sixty minutes (the length of the tape), this 16mm film lasts ten minutes.
21 Nauman in Willoughby Sharp, 'Interview with Bruce Nauman', 1971, in Kraynak (ed.), *Please Pay Attention Please*, p. 148.
22 Ibid., p. 122.
23 On the relationship between Nauman and Beckett see 'Human Condition/Human Body: Bruce Nauman and Samuel Beckett', in *Image/Text*, London, Hayward Gallery, 1998 and *Samuel Beckett, Bruce Nauman*, Vienna, Kunsthalle Wien, 2000.
24 The looping of the videos was also inspired by the films of Andy Warhol and Nauman's interest in the infinite compositional structures of Philip Glass, John Cage and La Monte Young.
25 Nauman in Marcia Tucker, 'Bruce Nauman', in Jane Livingston and Marcia Tucker, *Bruce Nauman: Work from 1965–1972*, New York, Washington and London, Los Angeles County Art Museum, 1973, p. 41.
26 The recording camera is mounted sideways.
27 Van Bruggen, *Bruce Nauman*, p. 19.
28 Ibid., p. 9.
29 Nauman in Sharp, 'Interview with Bruce Nauman', p. 153.

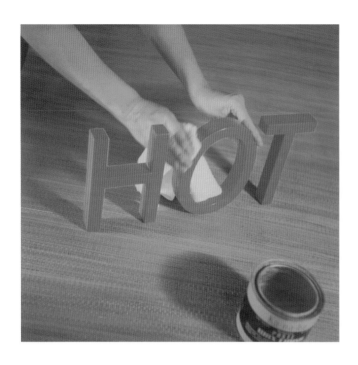

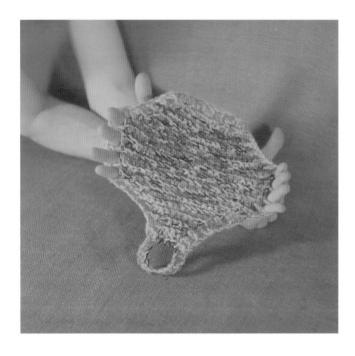

Top: *Waxing Hot* 1966-7/70
Bottom : *Untitled (Pot holder)* 1966-7/70

Top: *Finger Touch No. 1* 1966-7/70
Bottom: *Coffee Spilled Because the Cup Was Too Hot* 1966-7/70

Right: *American Violence* 1983
Below: *Double Face* 1981

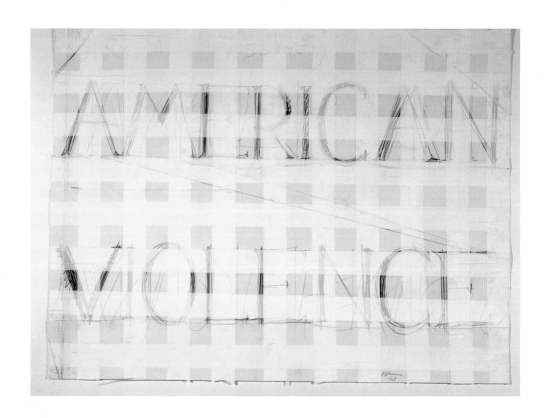

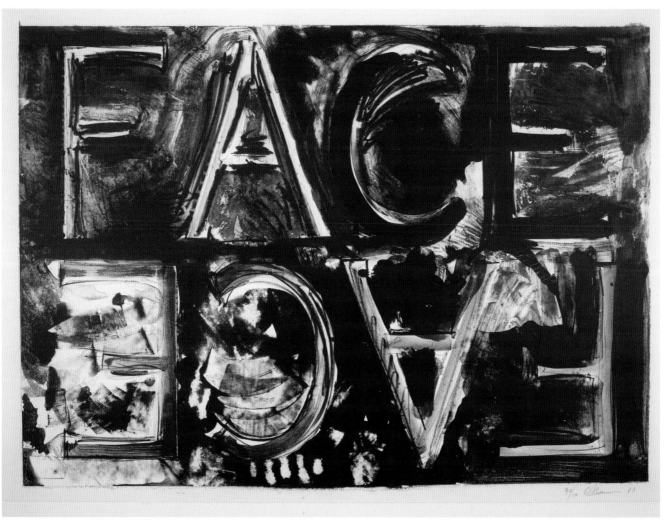

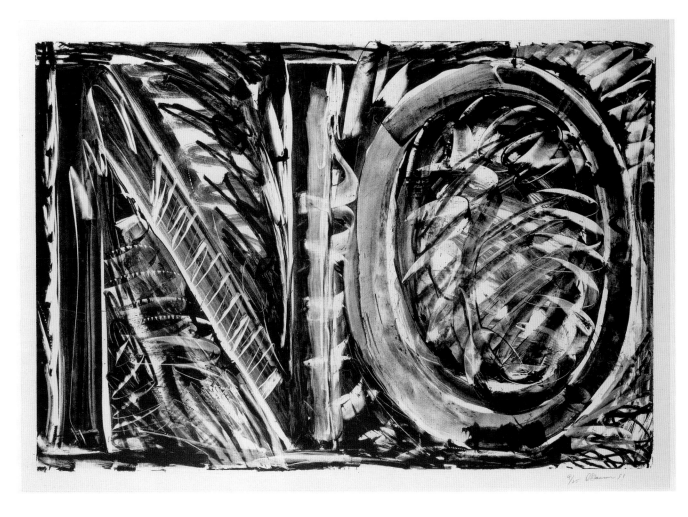

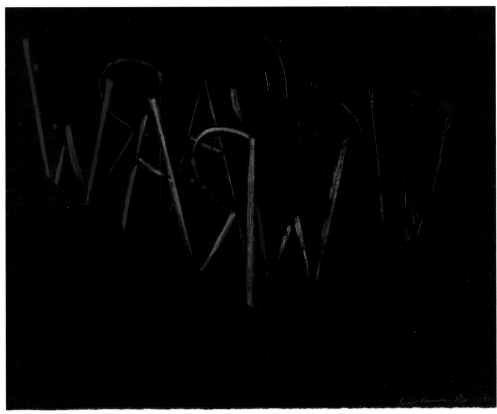

Above: *No (Black State)* 1981
Left: *Raw-War* 1971

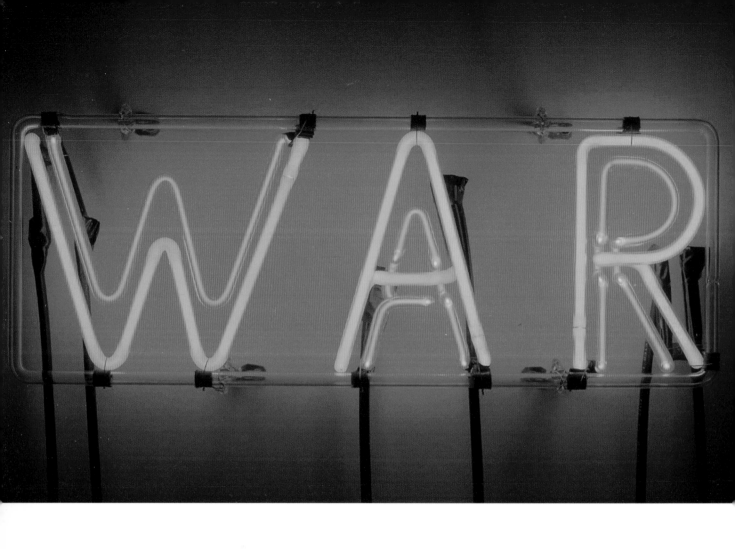

Raw War 1970

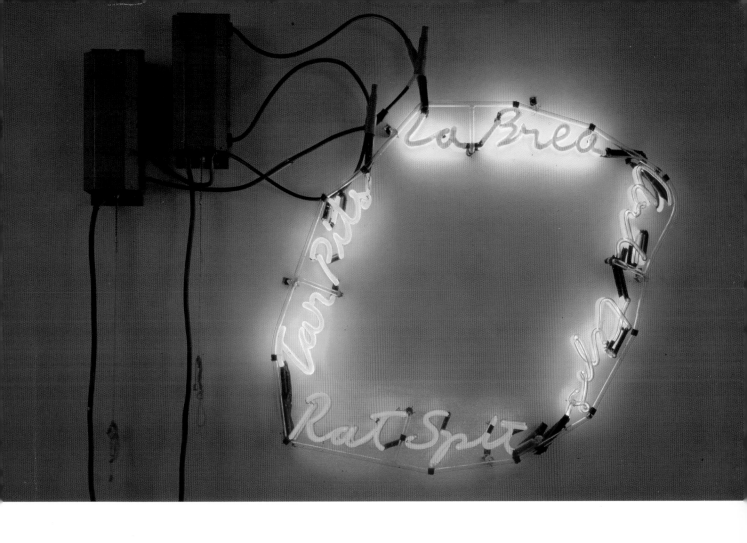

La Brea/Art Tips/Rat Spit/Tar Pits 1972

Following pages: *Human Nature/Knows Doesn't Know* 1983/6
Make Me Think Me 1994
Life Fly Lifes Flies 1997

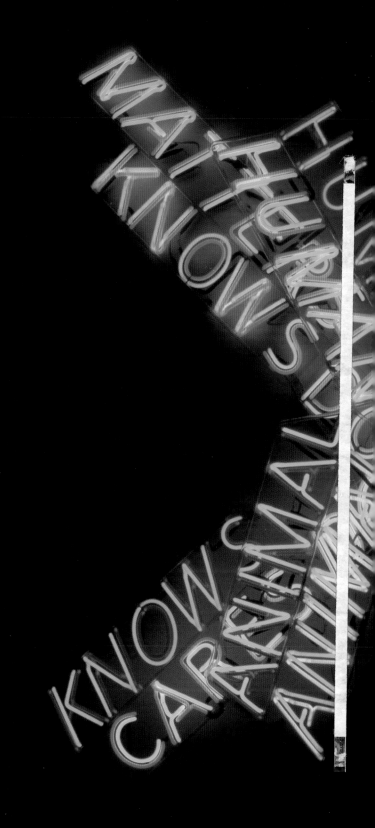

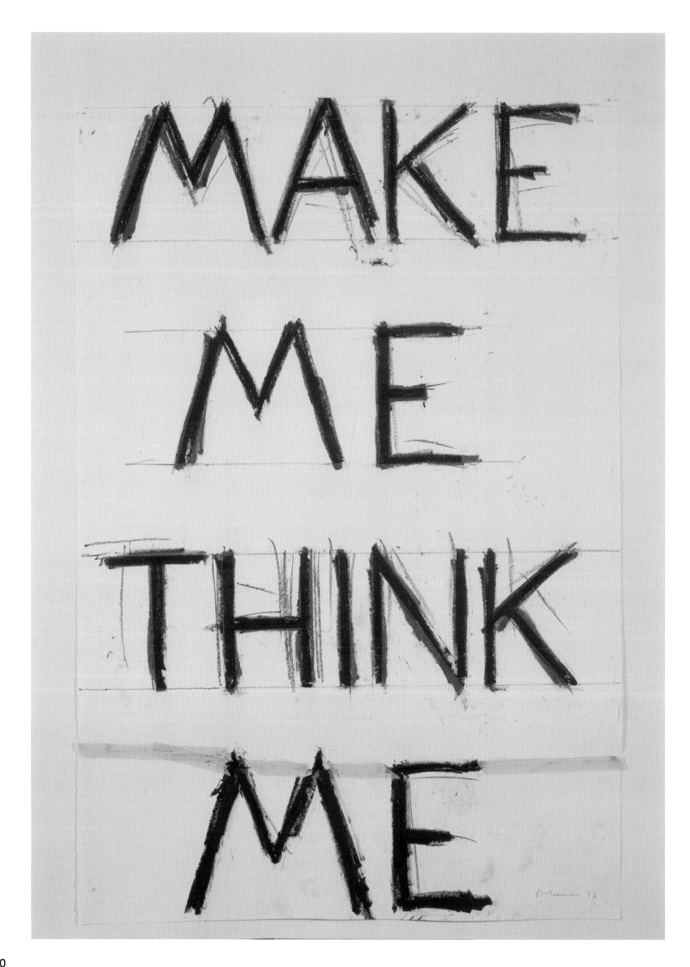

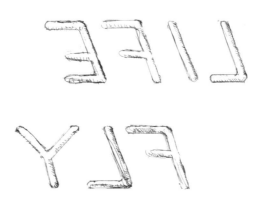

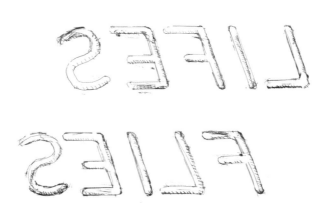

PROCEDURES PERFORMED AND EXECUTED

Johanna Drucker

In 1968, Bruce Nauman created one of his earliest word works: *RAW WAR*. The pale outline of the letters is drawn in pencil in a three-line grid, with blood-red watercolour emphasising letters in a diagonal R, A, W from upper right to lower left, and then across the bottom row W, A, R. This sketch study contains various working notes, including the statement 'a sign to hang up when there is a war on'. 1968. America was deeply embroiled in Vietnam. Protests were rising. Artist activist groups mobilised alongside hundreds of

Following page: *RawWar* 1968

sign to hang when there is a war on

This size or up to 6 FEET LONG

WAR

1

WAR

2

WAR

3

This size or up to 6 FEET LONG

thousands of citizens to stop the war. In New York the year before, the Artists' and Writers' Protest had assembled the Collage of Indignation. Angry Arts Against the War organised a week of activities. 1968 was also the year of revolution: students and workers struggled on barricades in the streets of Paris and other European capitals. *RAW WAR* was timely and aggressively clear. It prefigures the brash directness of much of the work that was to come. Nauman made the piece in two other iterations, an edition of neon renderings (1970) and a print (1971). This exploration of media signals as much as the linguistic message about the way Nauman was situating himself within the possibilities of late-1960s' art. He was interested in the conceptualist use of multiples, minimalist aesthetics and industrial materials, as well as hand-painted pop meets activist sensibilities.

Nauman was a young man, an artist just finished with his degree, finding his way from painting and its seductive studio traditions in a period when conceptualism, minimalism and pop were all ascendant. The late sixties were characterised by tremendous cultural upheaval and change, clichéd as it is to say so. But the aesthetic field was a battleground – and not only for thematic expression of activist issues. At stake were ideas about the definition of fine art and its efficacy as a symbolic discourse. In the broader culture, the struggles of the old left were being reformulated as the challenge of a new. That transition shifted attention from labour organising and political infrastructure to struggles waged over control of the symbolic – in media, language and representation. The question of what role artists had in the massively influential realms of media was wide open. Visual art activity had tipped on a fulcrum in mid-decade, away from traditions of individual expression and medium-specific form-giving towards work that was in active dialogue with mass media, material culture, industrial production and symbolic discourse. But precisely what interests that dialogue would serve – and how, through what means it might be effective – was unclear. Nauman's work couldn't answer all of these questions, but it was very much conceived and executed within their frame.

RAW WAR is a striking piece for its time and ours. Unsubtle and direct, the work is regrettably still valid. A war is still on. The sign is to be kept hanging. But what of the legacy of the aesthetic debates of the 1960s? True, political attention shifted towards systems of media as the site for future political struggles. But they were also modes of distraction, entertainment, allure, and unprecedented proliferation of visual and material cultural forms. What was fine art to be and do in such a changed environment? Nauman is not a 'political' artist. He's a symbolic artist in an age of mass media, demonstrating the dialogic identity of fine art in its relation to other forms. His brash and aggressive

work acts out. It rejects decorum. It uses video and screen images to assault the viewer. It creates spaces and structures that constrain and coerce. And it screams with energy against the hypocritical repressive regimes of normative discourse. All the while, his work has often taken up the bright, vivid, colourful and even playful look of mass culture (and often the low-resolution, grainy, unfussy look of minimalist work). When it is consumable and lively, Nauman's work flaunts its pop sensibilities among the conceptualists, while pursuing a procedural mode of mediated performance work.

Of the many strains of fine art vying for Nauman's attention in the 1960s, conceptualism was the most important. Conceptualism shifted the ground on which fine art conceived of itself and its justifications. Conceptualism changed the rhetoric and terms of self-validation by asserting that the 'idea' was more crucial than the form of a work. In such a framework an 'idea' exists independent of execution. The concept of a work is understood and articulated in language, as a set of statements that are meant to be executed. Idea and execution are aspects of a productive, iterative process. Pop bequeathed permission to admire and adulate the material means of mass culture, but also to make use of its means of production. Conceptualism established a method of art production that gave it a high ground on which to distinguish itself from mass culture. By the 1960s, fine art couldn't compete with the production values of media culture. The most ordinary glossy magazine had higher photographic and print values than anything being done in a fine art atelier, if one is looking just at the industrial strength of seductive gloss. By retreating to the realm of idea, fine art could claim its identity within the rarefied sphere of conception values. From that point on, ideas were to be what made 'art' art.

In its first version, RAW WAR is obviously an early work, amateurish in conception and realisation. It's the work of a young artist trying to figure out what shape his work will take and how he will position himself. By his own admission, Nauman was struck by the painted words on the canvases of Ed Ruscha. Other artists, such as John Baldessari and Lawrence Weiner, had done block lettered canvases and wall pieces that established 'language art' within conceptualism's frame. And Joseph Kosuth had already demonstrated that flexible neon tubing could be shaped to spell words in artworks, not just commercial signs. Nothing in RAW WAR is invented by Nauman, but along with the Eleven Color Photographs executed in 1966–67, and video pieces done in 1968, it contains some fundamental elements of Nauman's work. These characteristics are procedural and iterative, idea-based but executed, and touched by an aggressive, confrontational attitude that is often accompanied by touches of flat, wry humour.

PROCEDURES PERFORMED AND EXECUTED

Nauman's work is language-based as well as performative. The 'linguistic turn' in the visual arts is certainly contemporary with his initial formation as an artist, but that phrase after all has its origins not in visual art, but in the history of philosophy and theories of mind; it points to a much earlier twentieth-century period in which metaphysics are abandoned by logical positivism and the systematic character of language comes to be perceived as a model for semiotic analysis across humanities and social science disciplines. By the mid-twentieth century, the idea that philosophy is concerned with language as a (some would argue *the*) primary object of study was already an established and non-controversial fact. But by the 1960s, the period of conceptualism's emergence, the impulse driving philosophical investigations of language was the quest for a link between natural language and the formal languages of computing.

The relation between conceptual art and the increasing popular attention to

Study for First Poem Piece 1968

things digital quickly became clear. Two major exhibitions of conceptual art, held at the Jewish Museum and then MoMA in New York, were titled *Software* and *Information*. The work in these exhibitions wasn't merely linguistic, it was procedural. This wasn't just 'work about language' or 'work using language'. It was the capacity of language to *do* something that brought conceptual art and programming into alignment, even if it was difficult to say precisely what that alignment was. The gaps between natural and formal language, aesthetic concerns and administered culture, rhetorical means and instrumental approaches, are non-traversable gulfs separating the domains of digital processing and conceptual art. But in a general sense the notion that an 'idea' was a set of statements and that their execution created a work allowed for a rough parallel: line-command programming and the execution of its outcome could serve as a general description of art-making as well as computational activity.

Study for the First Poem Piece 1968 shows just such iterative and combinatorial sensibilities. The work is laid out in a table, like entries in the fields of a database. Some colums of values are present, some absent, some complete. The poem is 'composed' from this field of possibilities and in the study the diagrammatic character of this process is revealed. *Study* isn't a digital work, and it is unable to be computed in electronic form, but it is computable as a set of combinations to be played with. In its final form, the work was engraved in regular columns on a large steel plate, with tiny, very straight and very delicate

Self-Portrait as a Fountain 1966-7/70

lines holding its seven words suspended in a wire-like mesh suggestive of circuitry. Its text elements, 'You May Not Want To Be Here', can be read in any number of ways. By eliminating one or more words from each line, Nauman simulates a software program running through an if/then procedure of selection or omission. The neutral, mechanical typeface in which the words are inscribed reinforces the sense of automation.

The procedural turn also has precedents. The first 'how to make a poem' recipe, put together by Tristan Tzara in the 1910s, was very simply a set of instructions for random composition. The Dada instructions may have been a deliberate slap in the face to creative self-expression, and they were hardly widely imitated, but the important move had been made: a work was created by rules, and those could be made explicit. Marcel Duchamp, that ever clever postmodernist *avant la lettre*, extended that Dada instruction-based sensibility. The nominalist strain of his work – naming, signing, designating – is striking for its linguistic affinities. The generative activity of creating a

work as the expression of a procedure anticipates the core principles on which conceptualism operates. The *Standard Stoppages*, much of *The Large Glass*, the dust collections, and other works in Duchamp's oeuvre are procedural in nature, brought about through following a step-by-step set of rules.

Dada, Duchamp, and other early experiments were clearly behind him, but Nauman's own contributions are indebted to none of these artists in particular. The execution of the 1966–67 project *Eleven Color*

PROCEDURES PERFORMED AND EXECUTED

Photographs should make clear how distinctively Nauman's personality stamped his conceptual proceduralism. *Self-Portrait as a Fountain* is irreverent, like a child's mischievous act. It has a look-at-me bravado to it. How can he be snapping a picture while also spouting water from his mouth? The stop-action is as much Buster Keaton slapstick sight-gag humour as it is a work of fine art. But the punning playfulness of *Waxing Hot*, *Eating my Words*, *Drill Team* and *Bound to Fail* are cleverly literal visual word-games. Not all of the *Eleven* are based on puns, however, and though these are still photos, the underlying kineticism of the acts involved hints at the actions in his signature neon sculptures and videos. *Coffee Spilled Because The Cup Was Too Hot* and *Coffee Thrown Away Because It Was Too Cold* document actions that have to be taken at their stated value, while *The Finger Touch with Mirrors* is clearly a momentary image of a performance work, action-based, with connections

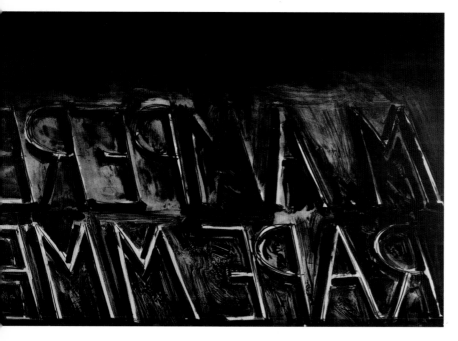

M Ampere 1973

to the *Body Pressure* piece Nauman did in 1974. The colour in the photographs makes them remarkable, since so much photography done within conceptualism was deliberately bland, black and white, flat-footed and anti-aesthetic in its stated intention (whatever the real effect). Among conceptual artists, Nauman's fellow Californian John Baldessari shared his use of colour as well as a sense of humour (though Baldessari makes a study and subject of colour, he doesn't simply make colour images). Colour shifts the visual key of *Eleven Photographs* towards mass culture artefacts, away from the photographic protocols of fine art, where the restrained palette and highly regulated aesthetic production values of black and white darkroom still reigned. The *Eleven Color Photographs* are procedural only in the most fundamental sense. They are deliberately executed ideas given specific form for the purpose of documentation. The idea for the work as a whole, and for each image, has a linguistic base. By following this instructional code they can be brought into being. But the language in and titling of these photographs is largely descriptive.

By contrast, *Run from Fear, Fun from Rear* 1972 is an utterance using direct address, even an imperative voice. It is a command to action, and like the *M Ampere* 1973 done a year later, it has explicit sexual connotations. The performance is

requested from the viewer as much as it is being offered as spectacle, but the vivid neon rendering gives it a classic bar/diner-sign look. Neon light and fluorescent tubes had their own history in contemporary art by this point. Martial Raysse, part of the French conceptual Nouveau Realisme movement, had made neon sculptures in the early 1960s that Nauman knew and liked. Dan Flavin had restricted

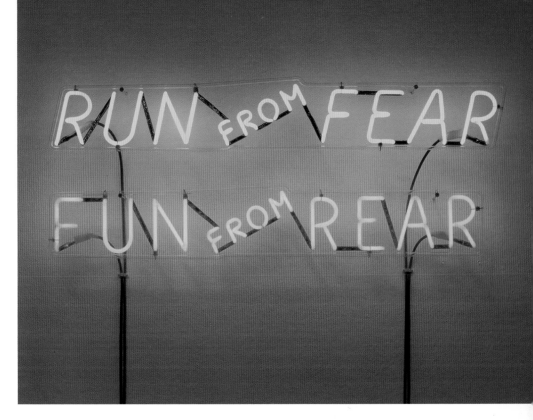

Run from Fear, Fun from Rear 1972

himself to exclusive use of fluorescent tubes by 1963. Nauman's 1969 performance and video *Manipulating a Fluorescent Tube* was remarkable for its low-tech, grainy, anti-aesthetic visual properties, with the streaking glow making traces in the gloom in demonstration of precisely the activity prescribed by the title of the piece. Nothing more, nothing less. Flavin was always either architectonic or atmospheric, bending and morphing space with his light, in a way that Nauman explored in the striking *Dream Passage* 1983. But for the most part, Nauman eschews both illusion and sublime experience. *Run from Fear, Fun from Rear* pulls us up short because it is first a banal instruction and then a perversely suggestive one through a single, simple twist of its form. *M Ampere* is darker yet, with its *Rape Me* subtext glimmering in reverse, the dark lithographic gloom illuminated with malevolent hints.

Duchamp wasn't the only twentieth-century artist from whom Nauman drew inspiration for his language-based works. Man Ray provided an impetus towards contradictory and irreverent work, and the writer Samuel Beckett's absurd attention to the banal but extraordinary character of human activity provided a model for a number of video pieces Nauman did in the late 1960s, including *Slow Angle Walk*, which is parenthetically titled *(Beckett Walk)*. Nauman's work isn't nonsense. It doesn't reject the normative orders of discourse and swap in elements that can't be made into sense. Nauman is a deformer, an artist for whom *détournement*, transformation of meaning through twisting form, is central.

PROCEDURES PERFORMED AND EXECUTED

Dada and surrealism are shot through with such displacements and acts of making strange, the epistemological defamiliarisation central to the avant-garde agenda. But in Nauman's hands the strange-making occurs in bright and banal modes. *Clown Torture* and *Mean Clown Welcome* are two violently assaultive works. Their use of the birthday or circus clown imagery and laughter as the basis of a repetitive, aggressive action is classic as a subversion of familiar meaning. Here again Nauman is far closer to the Wal-Mart and McDonald's world than he is to Commedia dell'Arte. The ideas Nauman took from fine art were about ways of making art, procedures and operations. The imagery and iconography of his work comes from a banal world of mass mediation, pop's playroom of neon and lettering, televisions and video screens, or else it borrows from the minimalist's lumber-yard aesthetic, with exposed construction, un-aesthetic rooms and corridors, steel cage

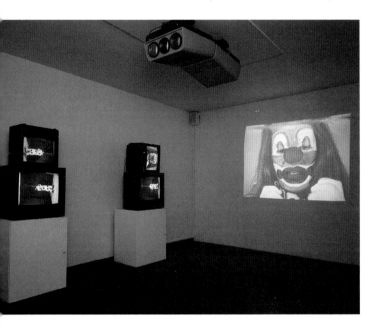

Clown Torture 1987

material, rubber or fibreglass. Art references, except for Duchamp, are almost non-existent. Nauman's attention was turned elsewhere, towards that hypnotising instrument of pure banality, the television and video screen, or towards the signage and activities of rather ordinary life.

The other contemporary source Nauman would have had for procedural models of art-making was Fluxus, where instruction-based art-making was well established and explored. Fluxus performances often consisted of a statement prescribing a single action or series of ordinary actions which were then to be carried out. Drop a string from a certain height, pour water from a jug to a glass while standing on a chair, turn headlights on and off, or do any of the many such activities indicated. *Body Pressure* 1974 has shades of Fluxus in its performance mode, following the explicit instructions for the piece that Nauman has outlined for himself. But the work also hints at the kind of duration performances that pushed at sustainable limits in the 1960s. In this case, however, the limit is simply that of decorum and behaviour. The final line of instructions states that this can become an erotic experience, and so we see Nauman, as is often the case, completing his act of performance and deformance with a sexual innuendo.

Nauman's work comes down, in many ways, to the issue of procedure and execution. It does so with a consistently low-production-value aesthetic, with as little conceit and artifice as possible, even though the artfulness resides entirely in setting up a process

that then manifests in an action, object, or effect. The wacky spirals of *Having Fun, Good Life Symptoms* 1985, like the blinking lights of *Human Nature/Knows Doesn't Know* 1985, repeat the grotesque carnivalesque feel of the *Double Slap in the Face* 1985. All are works from the mid-1980s, when postmodern theoretical premises reigned and the anti-visual aesthetic scourged gallery walls, purging them of special effects. These works have a blatant slapstick, aesthetically incorrect, aggressive vulgarity that goes against the subdued and critically distant didacticism of much 1980s' work. But Nauman's aesthetic engagement with neon and light, as well as with the iterative utterances of his *Good Boy, Bad Boy* 1985 work, has its roots in the 1960s' exuberant permission to make use of the media and materials of mass culture. In this sense it's right that his work be revisited now, when so many artists of the late 1990s and early 2000s are enthusiastically engaged in a studio-based, conceptually informed dialogue with the mass media.

Make Me Think Me 1994 is one of the more austere language works in this exhibition. The constitutive premise of its statement condenses the overall argument I've been trying to sketch here regarding Nauman's approach to language. His decision to create instruction-based works, command lines, utterances that ask for execution, was manifest again and again in different ways across the corpus of language pieces. To reiterate my earlier statements, this engagement with language isn't simply a part of a 'linguistic turn' in the visual arts. Nauman's approach is far more specific, particular to the 1960s era of his formation as an artist. The idea of language as system had gained currency early in the twentieth century. The notion of language as instructions, an algorithmic conceit, would dominate the second half. John L. Austin's famous *How to Do Things With Words*, first published in 1962, explored the concept of performative in distinction to descriptive language. Performative utterances had real effects, like royal commands, promises, or statements of law. The term was taken up in cultural studies and performance theory, in linguistics and in textual studies. Nauman's work is situated at the intersection of several 1960s-era artistic practices invested in the use of language – pop, performance and conceptualism. But his work also crucially helped define the distinctive 'procedural turn' that separates the early from the late modern, contributing to the foundation of much contemporary practice.

Sources
Coosje van Bruggen, *Bruce Nauman*, New York, Rizzoli, 1988.
Kathy Halbreich and Neal Benezra, *Bruce Nauman*, exh. cat., Minneapolis, MN, Walker Art Center, 1994.
Janet Kraynak (ed.), *Please Pay Attention Please: Bruce Nauman's Words: Writings and Interviews*, Cambridge, MA, and London, MIT Press, 2003.

Body Pressure 1974

Following page:
Shit in Your Hat – Head on a Chair 1990

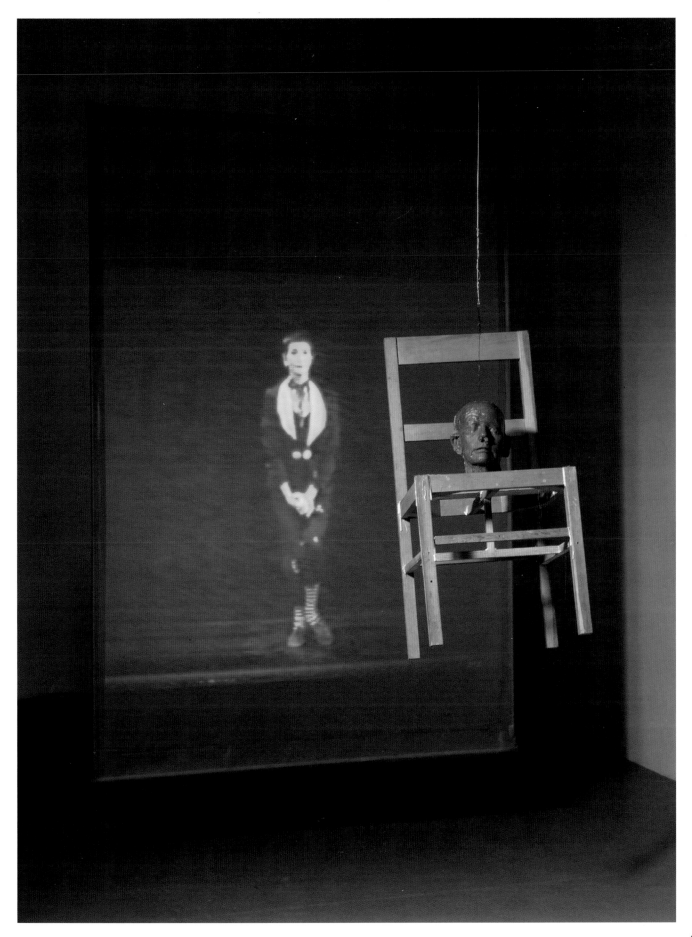

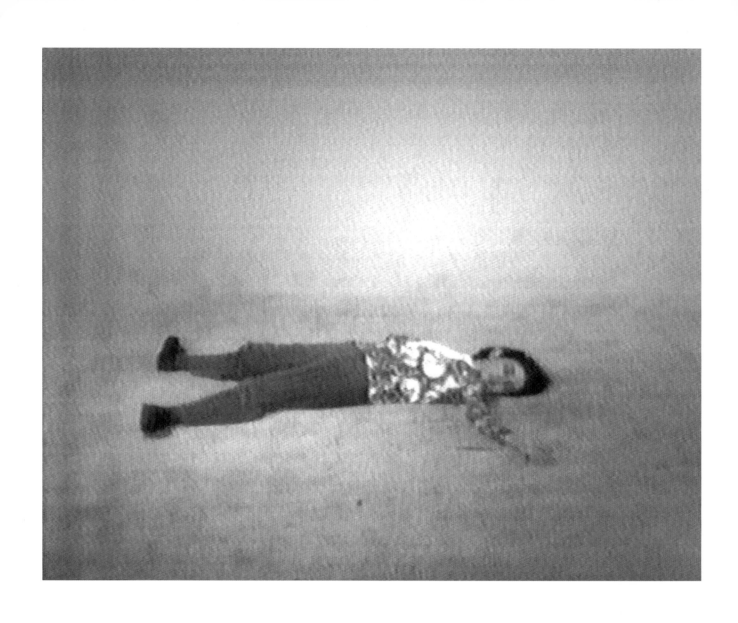

*Elke Allowing the Floor to Rise Up
Over Her, Face Up* 1973

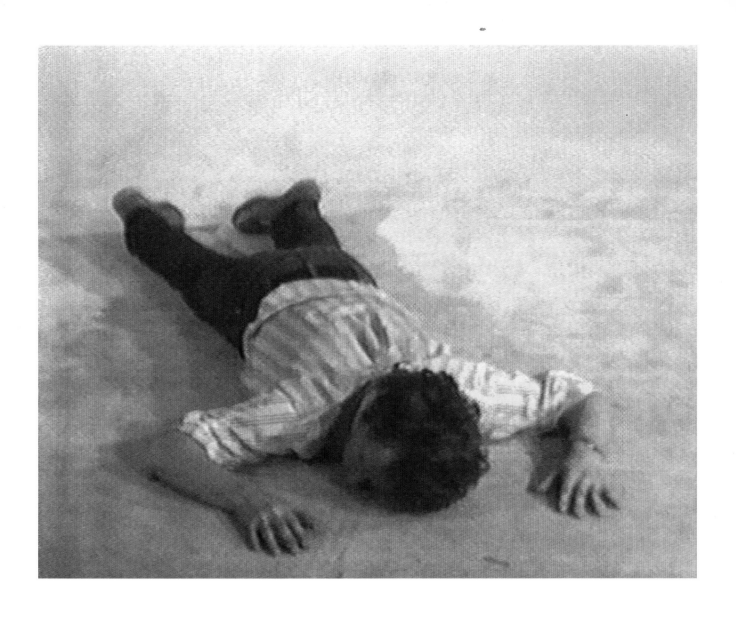

Tony Sinking into the Floor,
Face Up and Face Down 1973

BOUND TO FAIL: CONSTRAINTS AND CONSTRICTIONS IN BRUCE NAUMAN'S EARLY WORK

Anna Dezeuze

BRUCE NAUMAN BOUND TO FAIL

'I was just sort of tied in a knot and couldn't get anything out.'[1] 'Tied in a knot', Nauman struggled to create works in his San Francisco studio around 1966. In 1967, he declared himself 'bound to fail' in a photograph showing his arms tied behind his back by a rope. The colour photograph served as the model for a wax and plaster sculpture; to accompany the shift in medium, Nauman displaced his failure onto another sculptor

Following page:
Bound to Fail 1966-7/70

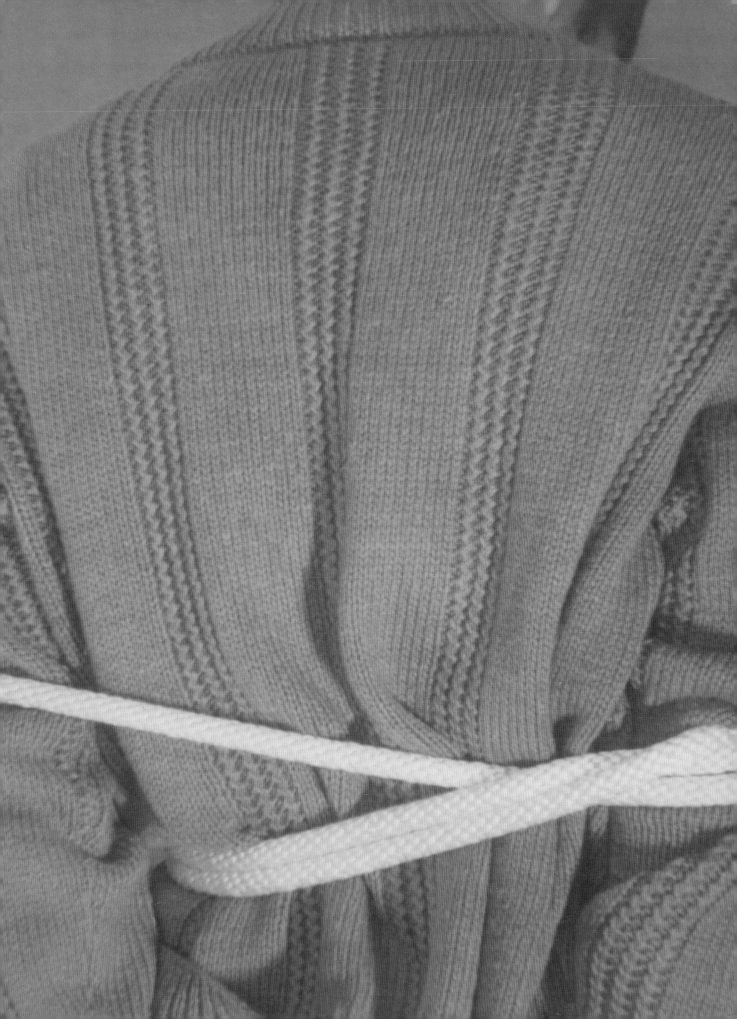

BOUND
TO FAIL

and called the sculpture *Henry Moore, Bound to Fail*. In a series of photographs sent to Bill Allen, Nauman used his thin frame, clad in the same oversize woollen jumper, to demonstrate 'three well-known knots'.

Like Samuel Beckett's character Murphy, who voluntarily binds himself to a chair, Nauman acknowledged failure as his starting point. Then he cast around for what he has called 'excuses' for making works: in this case, it was the pun contained in the expression 'bound to fail'.[2] Other colour photographs at that time revolve around puns evoking weakness ('feet of clay') and error ('eating my words'). One 'excuse' leads to another – a photograph becomes a sculpture, a bind is turned into a demonstration of Boy-Scout knowledge. And a sculpture of a failed sculptor becomes a sculpture about the failure of sculpture, insofar as Nauman's inept hand-modelling of *Henry Moore, Bound to Fail* serves to poke fun at the whole tradition of figurative sculpture itself.[3]

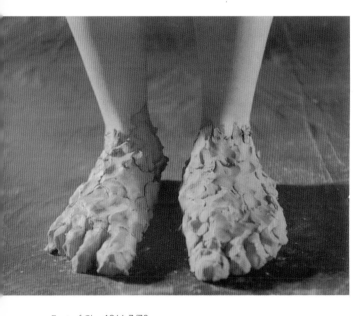

Feet of Clay 1966-7/70

Finding titles, according to Nauman, was a good way to feel 'more comfortable' about making works – to ease the bind of failure, so to speak.[4] The un-knotting trick involves testing the limits of art by disrupting traditional fields of competence such as sculpture or painting. Nauman's probing would also focus on the space of the studio as another framing structure of artistic practice. Here, again, the process started with a 'bind' – the artist's inability, alone in his studio, 'to think of different things to do every day'.[5] Once the problem was acknowledged to be one of filling time, Nauman only needed to examine what he was in fact doing in the studio – drinking coffee and walking around – and to turn that into the subject matter of his work. Rather than leaving Nauman in a state of paralysis, failure to produce within a given set of parameters led him to redefine those parameters: 'My conclusion was that I was an artist and I was in the studio, then whatever it was I was doing in the studio must be art.'[6]

In the visual arts, Man Ray's lack of stylistic and conceptual consistency seems to have served as an encouragement for Nauman. He may also have been struck by the sheer incompetence of some of the works included in the Dada artist's 1966 Los Angeles retrospective (even a sympathetic reviewer admitted that '[as] an individual artist, Man Ray is indeed uneven: brilliant in one moment, but unsuccessful in the next'[7]). By refusing to exhibit his photographs in this exhibition, Man Ray clearly emphasised a separation

between his professional work and his other creative output. Not relying on art for a living, Nauman believed, gave Man Ray and other Dada artists a significant freedom to experiment. For Nauman, who was earning a living through teaching and found himself with a great deal of spare time, experimentation involved adopting the role of an amateur dabbling in a wide range of pastimes. He used photography in his *Eleven Color Photographs* because he 'didn't know enough about photography to get involved in trying to make a really interesting or original photograph'.[8] He 'failed' at hand-modelling and chose what Anne Wagner has called 'traditional tokens of sculptural de-skilling' – casts and moulds – instead.[9] As to his relation to dance, Coosje van Bruggen has rightly pointed out that the appeal of his performances 'stems from […] the continuous threat of collapse, of losing his balance or otherwise failing technically, that comes from his amateur status in a professional field'.[10] Just as Beckett switched to French in order to avoid 'style', Nauman assumed the persona of the amateur as another effective way of probing the edges of art as a discipline.

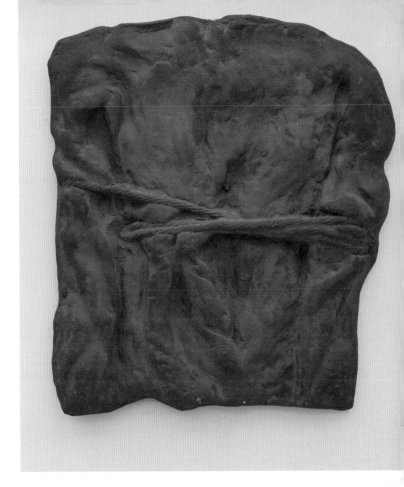

Henry Moore, *Bound to Fail* 1967
cast 1970

Many conceptual artists in the 1960s became amateur photographers. According to Jeff Wall, the attraction of photography lay in the fact that it had remained up to then relatively untainted by the rigid aesthetic criteria and commercial values associated with other media.[11] Moreover, by appropriating a medium in which they were not trained professionally, conceptual artists sought to mimic the unskilled persona of the amateur photographer who can access the everyday world outside the autonomous field of art. The notion that the amateur is somehow more honest and more sincere than the professional was appealing to many. 'If you really believe in what you're doing and do it as well as you can,' Nauman-the-amateur-dancer explains, 'there has to be a certain kind of sympathetic response in someone who is watching you.'[12] The amateur is at once intensely involved in the process and not good enough to be able to control the process entirely. This is why he can be the most direct link between the viewer and the original experience to which the work refers, thus eliciting a greater 'sympathy' with the work's subject-matter.

What sets Nauman apart from other conceptual artists, however, is that he has taken on different amateur personas, and done this repeatedly. What some critics perceive as a means to 'test himself over and over' signals for others an easy way out: after all, an amateur is not judged as harshly as a professional.[13] In this case, Nauman's attitude can be read as weakness – 'an inability to produce a total form of representation' – or, perhaps worse, sheer laziness, an indiscriminate 'use of whatever means are available to him'.[14] (When applied to a professional, 'amateur' becomes an accusation of idleness or incompetence.) Some of Nauman's comments do seem to invite such accusations, as when he explained that 'it just seemed easier' to make his

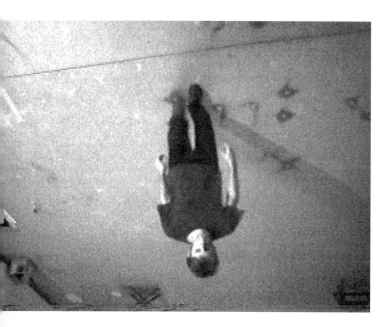

Stamping in the Studio 1968

Eleven Color Photographs as photographs rather than as paintings, which would have required more effort, or when he claimed he was happy to present his early sculptures 'in a straightforward way, without bothering to shine them and clean them up'.[15] Deciding to frame mundane activities such as drinking coffee and pacing around the studio as artistic outputs could also be interpreted as a sign of laziness. Although not directly influenced by Duchamp, Nauman's decision resonates with the attitude of the older artist, whose 'laziness', as Helen Molesworth has remarked, is 'nowhere [...] more evident than in the readymades, where he produced art with the least effort possible – buying it already made'.[16]

That Nauman distanced himself, in fact, from Duchamp's 'leisure attitude' because the Frenchman did not have to work to make a living, in contrast with the working-class Man Ray, may appear as an insignificant aside.[17] But this small point can help us to better situate Nauman's position in an intermediate space between Duchamp's wit and idleness, and Beckett's existential belief that 'to be an artist is to fail, as no other dare fail, that failure is his world and the shrink from it desertion'.[18] What Duchamp and Beckett have in common is a propensity for artistic experimentation driven by a sense of the limitations of art. But Beckett's brand of absurd tragi-comedy is permeated with a sense of anxiety and death which is decidedly played down by Duchamp's pose as a cool, ironic joker who invariably turns his disenchantment with the world into a subject for pranks, thus mocking all values, including his own.[19] As a 'smartass perpetrator of aesthetic practical jokes', according to Arthur Danto, Nauman's attitude of laziness and playfulness suggests Duchamp's deadpan

irony.[20] But his sense of moral responsibility and existential questioning brings him closer to Beckett's outlook. It is difficult to imagine Duchamp observing that the 'artist's freedom to do whatever he or she wants includes the necessity of making […] fundamental decisions' about lifestyle and work process.[21] Beckett, according to Gabriel Josipovici, concluded that 'since fiction is helpless in the face of reality, only the fiction of helplessness will be real'.[22] Nauman successfully developed a 'fiction of helplessness' by using the studio, like Duchamp, as a 'parodic chamber'.[23]

CONSTRAINING PARTICIPATION

The limits of artistic practice that Nauman was investigating in his studio were carried over in his participatory works, started in 1969, through the means of precise instructions and physically constricting environments. Speaking about his corridor installations, Nauman made his position very clear: 'I mistrust audience participation. That's why I try to make these works as limiting as possible.'[24] Since Nauman had wanted his studio films to be less about him as an individual and more about human beings in general, instructions and environments naturally presented themselves as means by which to generalise his experiences to others. Only limiting structures and notations, however, could guarantee that people would 'have at least a similar kind of experience'.[25] And the main common denominator from which these experiences could emerge, it seemed, was the participant's body.

Nauman's participatory instructions tend to privilege the intersection between mental and physical exercises: a 1969 'mental exercise' invites the reader to lie on the floor and allow himself or herself to 'sink into the floor', while the instructions for the 1974 *Body Pressure* involve pressing one's body against the wall, imagining an image of oneself pressing against the other side of the wall, and then beginning to 'ignore […] the thickness of the wall'. While such exercises emerged from Nauman's self-explorations in the studio and maintain a strong link to architectural space, they were no doubt encouraged by his interest in Gestalt therapy. When he states for example that '[an] awareness of

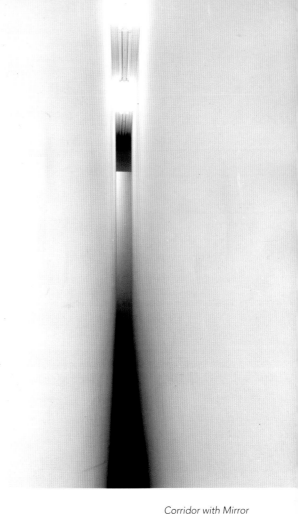

Corridor with Mirror and White Lights 1970

yourself comes from a certain amount of activity and you can't get it from just thinking about yourself',[26] Nauman seems to be echoing the authors of a 1951 manual on *Gestalt Therapy* who explain that 'the observation of your self in action' is far more effective than introspection.[27] Nauman's exercises share with some of the Gestalt 'techniques of awareness' a focus on specific body parts, an emphasis on *feeling*, rather than visualising, images of oneself. What is striking about some of these Gestalt exercises is their strong visual character, and the way they are presented in a step-by-step process, directing the mind to become aware of different elements at a time. These characteristics are precisely those that contribute to mark Nauman's instructions off from other kinds of scores, such as those produced by Fluxus artists in the 1960s, which tend to privilege temporal, rather than spatial, experiences, and which do not usually specify either the progress, or the full outcome, of the exercise.

If Nauman's instructions serve to test the limits of the body by means of mental exercises, his environments are experiments in the relation between visual perception and the body's spatial self-awareness. Though Nauman insists that his mode of experimentation is more intuitive than scientific protocols, he employs a similar approach: in order to truly understand bodily functions, he focuses on what happens precisely at the moments at which they break down. As in scientific experiments, Nauman narrowed down the variables being tested; his pared-down apparatuses leave no space for other factors to interfere with the bare mechanisms of balance and self-perception in space. Indeed, the shape, length and width of corridors, the intensity of lights, and the images relayed on television monitors are means of directing movement and perception far more effectively than any instructions would.

In an untitled 1969 set of instructions, Nauman imagines a person living in a room in which a mirrored wall would reflect their image from the back rather than the front. '[A]fter a number a years,' Nauman surmises, 'the person would no longer recognise his relationship to his mirrored image.'[28] In some of his corridors, Nauman used closed-circuit video 'as a kind of electronic mirror' and when we see our 'reflection' from the back, sometimes advancing away, rather than moving towards us, we do indeed experience a fleeting sense of doubt as to where, and who, we are.[29] What is confusing, Nauman observes, is when two types of information don't add up: we are aware of where we are and what direction we are moving in, and yet this mirror/monitor is telling us otherwise. According to Parveen Adams, this involves nothing short of a 'fleeting disappearance of the viewing subject'.[30] In Nauman's video-corridors, Adams argues, the subject is split

along the axis of surveillance, which is revealed to structure his or her own self-perception. As in the instructions, Nauman focuses our attention on our body only to force us to experience its limits.

For Nauman, artists who allow audiences too much freedom to alter artworks encourage a definition of art itself as a game. 'But game-playing doesn't involve any responsibility,' he objects, 'and I think that being an artist does involve moral responsibility.'[31] The notion of responsibility, which helped define Nauman's attitude as he was exploring the space of the studio, re-emerges here as a 'mistrust of audience participation'. Many artists in the 1960s celebrated spectator participation as a form of play. The Brazilian Hélio Oiticica, for example, conceived his 1969 *Eden* as a space of leisure, where visitors, wandering barefoot through sand, water and leaves, listening to music in tents, and relaxing in curtained beds, could encounter a space for self-discovery and creativity unconditioned by socio-economic demands.[32] To this embrace of play as a tool for political liberation, Nauman opposes a negative notion of 'game-playing', which implicitly criticises such experiments as trivial and naïve. Janet Kraynak has suggested that Nauman's 'mistrust' of participation is related to the broader context of an emerging 'programmed society' in which participation is coerced by social, political and cultural manipulation, and choice is an illusion.[33] Rather than a rhetoric of freedom and creativity, Nauman's environments mobilise devices of confinement, oppression and control, commenting on a new kind of capitalist society in which ideas of efficiency and management have permeated every sphere of experience, including leisure. The only possibility for 'weak participants' to resist this programmed society is to look for 'small opportunities where conformity breaks down'.[34] Similarly, argues Kraynak, Nauman's environments exploit the interstices between constraints and individual, uncontrolled experiences.

Nauman's definition of art as a 'hit at the back of the neck' is often quoted as a description of the moments of disorientation, shock and amusement that characterise his work.[35] Yet another of Nauman's images, used to describe the specific experience of his environments, seems to capture these interstices more accurately: the sensation of 'going up the stairs in the dark, when you think there is one more step and you take the step, but you are already at the top and have that jolt and it really throws you off'.[36] This was precisely the 'extremely rude and disagreeable' 'shock' described, almost two and a half centuries ago, by Edmund Burke in his *Philosophical Enquiry into the Origin of our Ideas of the Sublime and Beautiful*. Burke locates this jolt – which can be a trigger for the

Sublime – in the combination of a sudden 'relaxation' (of the leg, finding no resistance in its downward movement) followed by a sudden 'convulsion'.[37] When the body suddenly relaxes as one goes to sleep, Burke notes, this can also produce a 'violent start'. This start is often 'preceded by a sort of dream of our falling down a precipice', which he explains by the fact that 'parts relax too suddenly, which is in the nature of falling'.[38] Strikingly, Nauman himself made the same connection, as he compared the 'mis-step' experience to a specific moment in the viewer's journey through the corridors: 'When you realised that you were on the screen, being in the corridor was like stepping off a cliff or down into a hole'.[39] The sequence of relaxation-as-fall followed by a 'convulsion' conjures an image of a reflex experience based on absence and inevitability, like the invisible pull of gravity. As Steven Connor has remarked, the fear running through Nauman's work is that of letting the ground disappear beneath one's feet.[40] This dreaded 'pain of the mid-air' is none other than the 'sudden relaxation' that beckons the subject's dissolution. Nauman's work, I would suggest, operates through a 'contractile' logic, a dynamic movement between vertiginous free-fall and extreme constriction, between the 'disappearing subject' and the amplified reassertion of a responsible 'I'.[41]

'In a situation of idleness,' Roland Barthes observed, 'the subject is almost dispossessed of his consistency as a subject.'[42] However lazy, Nauman, like Duchamp, has never abandoned his 'I' as an artist. Unlike Duchamp, however, he has taken this threat seriously: investigating mechanisms of failure, limits and constraints, Nauman has probed, invited, and – often barely – kept at bay the dissolution of the 'I'.

1 Michele de Angelus, 'Interview with Bruce Nauman, May 27 and 30, 1980', in Janet Kraynak (ed.), *Please Pay Attention Please: Bruce Nauman's Words: Writings and Interviews*, Cambridge, MA, and London, MIT Press, 2002, p. 236.
2 Ibid.
3 See Anne Wagner, 'Henry Moore's Mother', *Representations*, no. 65, Winter 1999, pp. 93–4.
4 De Angelus, 'Interview with Bruce Nauman', p. 236.
5 Willoughby Sharp, 'Nauman Interview, 1970', in Kraynak (ed.), *Please Pay Attention Please*, p. 118.
6 Ian Wallace and Russel Keziere, 'Bruce Nauman Interviewed, 1979 (October 1978)', in ibid., p. 194.
7 Carl I. Belz, 'A Man Ray Retrospective in Los Angeles', *Artforum*, Dec. 1966, p. 23.
8 De Angelus, 'Interview with Bruce Nauman', p. 267.
9 Wagner, 'Henry Moore's Mother', p. 94.

10 Coosje van Bruggen, *Bruce Nauman*, New York, Rizzoli, 1988, p. 50.
11 Jeff Wall, '"Marks of Indifference": Aspects of Photography in, or as, Conceptual Art' (1995), in Douglas Fogle (ed.), *The Last Picture Show: Artists Using Photography, 1960–1982*, exh. cat., Minneapolis, Walker Art Center, 2003, pp. 32–44.
12 Willoughby Sharp, 'Interview with Bruce Nauman, 1971 (May 1970)', in Kraynak (ed.), *Please Pay Attention Please*, p. 148.
13 Van Bruggen, *Bruce Nauman*, p. 105.
14 Pamela Lee, 'Pater Nauman', *October*, no. 74, Fall 1995, p. 131.
15 Sharp, 'Nauman Interview, 1970', pp. 121, 115.
16 Helen Molesworth, 'Work Avoidance: The Everyday Life of Marcel Duchamp's Readymades', *Art Journal*, vol. 57, no. 4, Winter 1998, p. 59.
17 De Angelus, 'Interview with Bruce Nauman', p. 233.
18 Samuel Beckett, *Proust and Three Dialogues*,

London, Calder, 1965, p. 125.

19 For a discussion of Duchamp as a 'joker', see Jeffrey Weiss, *The Popular Culture of Modern Art: Picasso, Duchamp and Avant-gardism*, London and New Haven, Yale University Press, 1994, chapter 3. Amelia Jones has analysed the repression of death and trauma in Duchamp and Man Ray's works in *Irrational Modernism: A Neurasthenic History of New York Dada*, Cambridge, MA, and London, MIT Press, 2004, chapter 2.

20 Arthur C. Danto, 'Bruce Nauman' (1995), in Robert Morgan (ed.), *Bruce Nauman*, Baltimore and London, Johns Hopkins University Press, 2002, p. 150.

21 Wallace and Keziere, 'Bruce Nauman Interviewed', p. 194.

22 Gabriel Josipovici, 'Samuel Beckett: The Need to Fail', in Boris Ford (ed.), *The New Pelican Guide to English Literature*, volume 8, Harmondsworth, Penguin, 1983, p. 160.

23 Weiss, *The Popular Culture of Modern Art*, p. 119.

24 Sharp, 'Nauman Interview, 1970', p. 113.

25 Jan Butterfield, 'Bruce Nauman: The Center of Yourself, 1975', in Kraynak (ed.), *Please Pay Attention Please*, p. 182.

26 Sharp, 'Interview with Bruce Nauman, 1971 (May 1970)', p. 142.

27 Frederick S. Perls, Ralph F. Hefferline and Paul Goodman, *Gestalt Therapy: Excitement and Growth in the Human Personality*, New York, Julian Press, 1951, p. 3.

28 'Untitled, 1969', in Kraynak (ed.), *Please Pay Attention Please*, p. 55.

29 Sharp, 'Interview with Bruce Nauman, 1971 (May 1970)', p. 150.

30 Parveen Adams, 'Bruce Nauman and the Object of Anxiety', *October*, no. 83, Winter 1998, p. 108.

31 Joan Simon, 'Breaking the Silence: An Interview with Bruce Nauman, 1988 (January, 1987)', in Kraynak (ed.), *Please Pay Attention Please*, p. 327.

32 See Hélio Oiticica, '[untitled text]', in *Hélio Oiticica*, exh. cat., London, Whitechapel Art Gallery, 1969, n. p.

33 Janet Kraynak, 'Dependent Participation: Bruce Nauman's Environments', *Grey Room*, no. 10, Winter 2003, pp. 22–45.

34 Ibid., p. 40.

35 Simon, 'Breaking the Silence', p. 319.

36 Sharp, 'Interview with Bruce Nauman, 1971 (May 1970)', p. 151.

37 Edmund Burke, *Philosophical Enquiry into the Origin of our Ideas of the Sublime and Beautiful*, London, 1759, p. 282. My thanks to Aris Sarafianos for this reference.

38 Ibid., p. 284.

39 Sharp, 'Interview with Bruce Nauman, 1971 (May 1970)', p. 151.

40 Steven Connor, 'Shifting Ground' (2000), online publication (http://www.bbk.ac.uk/english/skc/beckettnauman/), n. p. (This is the English version of Steven Connor, 'Auf schwankendem Boden', in *Samuel Beckett, Bruce Nauman*, exh. cat., Vienna, Kunsthalle Wien, 2000, pp. 80–7.)

41 I borrow the term 'contractile' from Aris Sarafianos, 'Burke's Contractile Sublime and the Making of the Modern Aesthetic of Contradiction', unpublished manuscript, 2005.

42 Roland Barthes, 'Dare to Be Lazy' (1979), cited by Molesworth, 'Work Avoidance', p. 60.

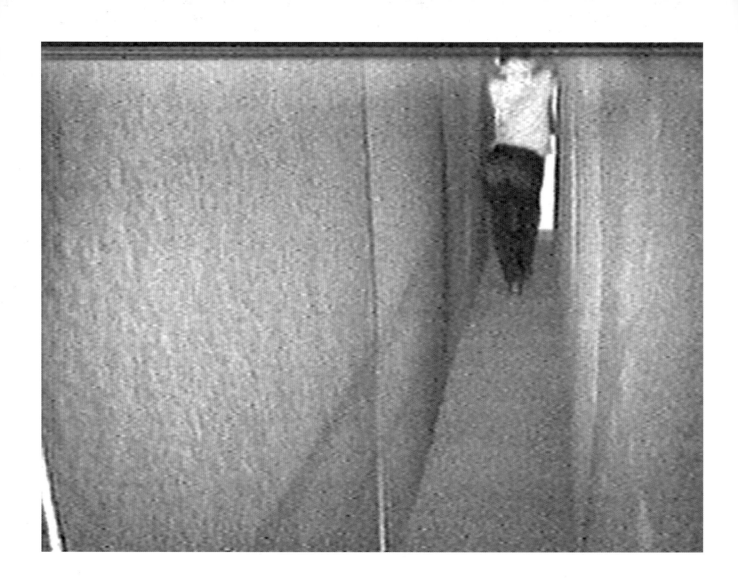

Walk with Contrapposto 1968
Following page: *Corridor Installation*
(Nick Wilder Installation) 1970

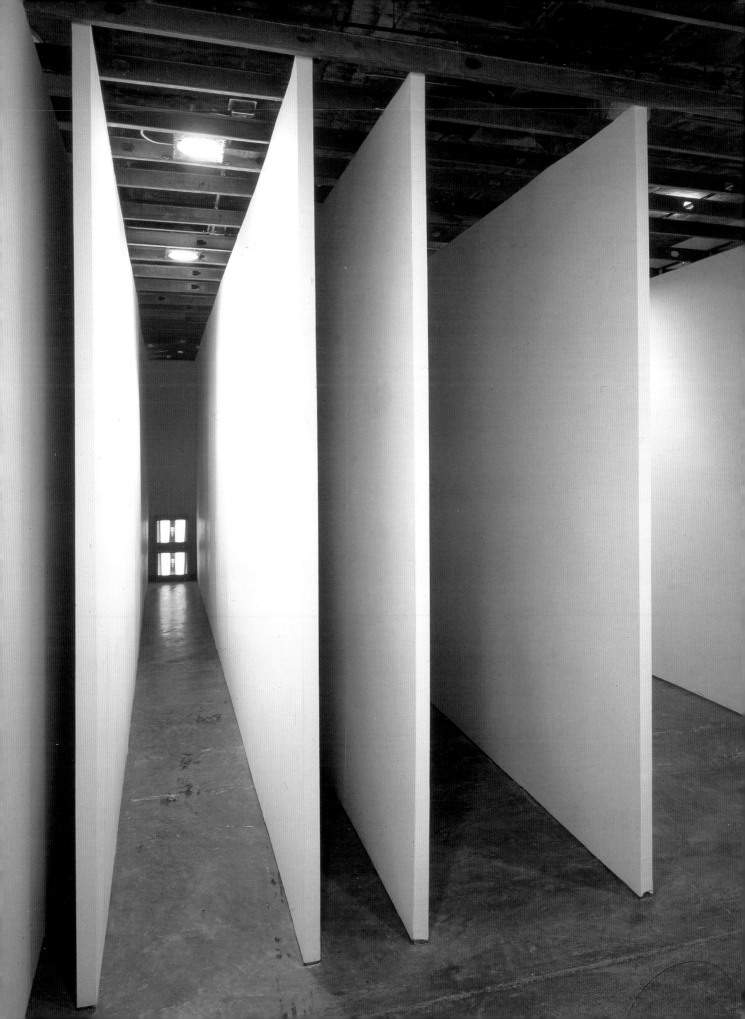

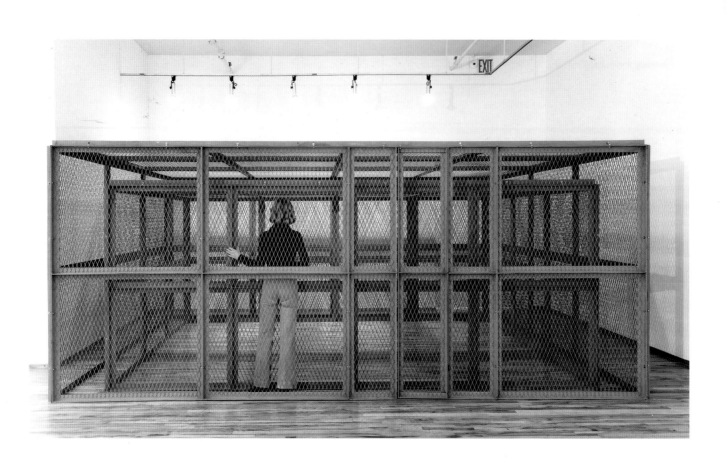

Double Steel Cage Piece 1974

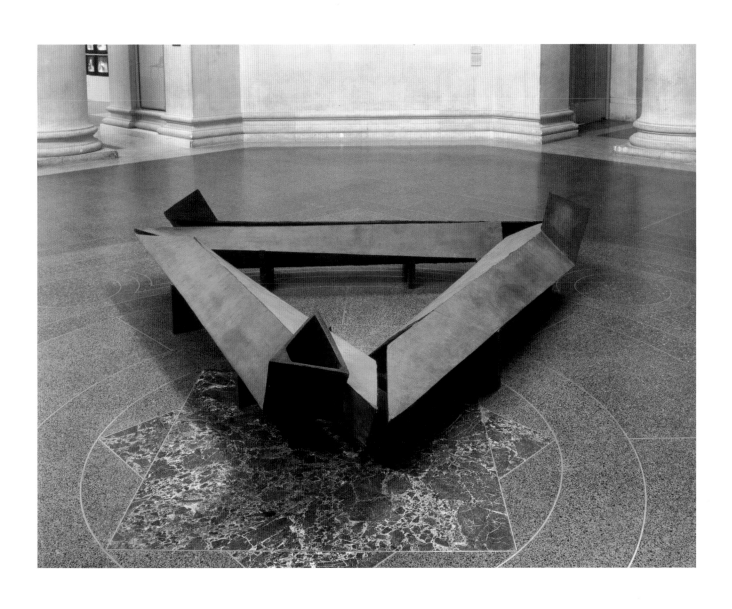

Three Dead End Adjacent Tunnels,
Not Connected 1981

DOING THE BECKETT WALK: PERFORMANCE, RITUAL AND GESTURE IN NAUMAN

Christoph Grunenberg

Following page:
Slow Angle Walk (Beckett Walk)
1968

In a brief yet powerful scene in *Badlands* 1973, a classic example of experimental Hollywood, Sissy Spacek performs a strange ritual in the grand salon of the 'rich man's house' she has invaded with mass murderer Martin Sheen. The chairs are arranged around the margins of the room; moving slowly from one to another, she sits down and adjusts her posture to each chair's shape. It is a tentative exploration of social difference, searching for what it feels like to inhabit a space imbued with the sense of self-assurance

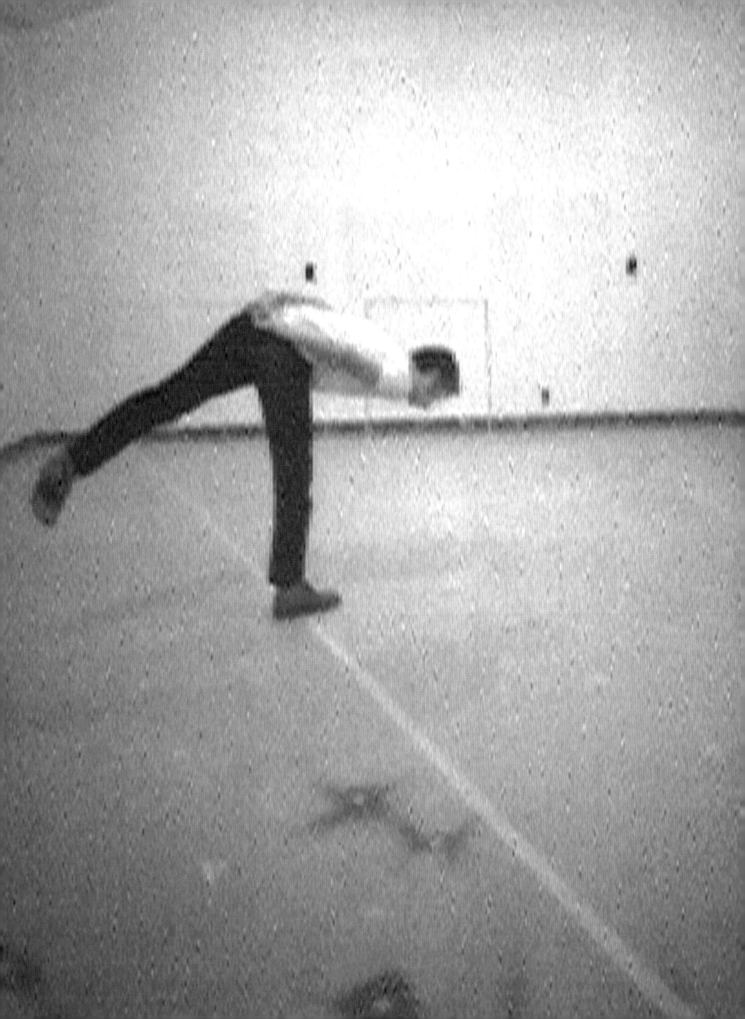

PERFORMANCE RITUAL AND GESTURE IN NAUMAN

that comes with lineage and affluence. The suspension of 'action' for the sake of a series of idle activities illustrates the quiet penetration into popular culsture of avant-garde practices that are typical for the period. The protracted narrative flow, artfully apathetic performances and sweeping shots of the flat and empty landscapes (the pathetic fallacy of the 'badlands' in the film's title) challenge the conventions of popular entertainment. The film further demonstrates a common concern with fundamental questions of anxiety, alienation and emotional desensitisation as articulated in the human propensity for extreme violence, which is presented here without judgment. It is the detached nonchalance and moral ambiguity with which the murders are executed that make *Badlands* such a compelling and disturbing film, blurring the distinction between art and mainstream cinema.

Badlands 1973

Bruce Nauman has followed a similar route of detached articulation, concerned primarily with the myths of art-making, intimate bodily processes and rituals, and hermetic linguistic and semantic conventions. His performance work confronts us with a register of relentlessly repeated gestures and unproductive actions in pursuit of some incomprehensible and ultimately unachievable objective. Nauman's protagonists are caught in some parallel universe from which there is no escape – the jumping head in the television box or the clown in its cubicle, the beholder trapped in a metal cage or halfway down a one-way corridor. Even as the artist leaves imprints of his own body in the cast sculptures and features as the lone protagonist in videos and photographs, Nauman has consciously removed himself from his art as subject and presents the audience with frequently circuitous and confrontational pieces. However removed, he is still present as author, performer and model rather than presenting specific art objects, sculpture or documentary evidence. He has made the successful transition from the 'theatricality' of the Minimalist object to the staging of an absurd theatre in which the artist and beholder are the central, if unwilling, characters.

Nauman shares with Marcel Duchamp and Jasper Johns the investing of 'brainy art gestures with psychological charge', as Peter Schjeldahl has observed, calling him 'a Barnum of introversion, embodying anxious or hostile states in broad jokes and spectacular displays'.[1] Charging eccentric and empty activities with psychological meaning, Nauman condenses everyday activities into highly structured dramas of depersonalised and abstracted action that address fundamental issues concerning the human condition. Despite Nauman's early self-imposed retreat to the creative refuge of the studio as primary stage, his investigation into human states of mind reflects wider debates in psychological and social sciences. He has always observed human behaviour with an anthropologist's curiosity, unremittingly rehearsing and dissecting everyday rituals and gestures in his studio experiments.

During the 1960s, performance and happenings had developed into an established genre of the New York downtown scene, characterised by an absence of narrative plot and with an emphasis on repetitive actions and carefully choreographed movements. We were no longer dealing with 'theatre' and 'acting' but with 'activities' that did not necessarily require an audience but in which the 'object of the aesthetic experience has become the self-perceived behaviour of an individual'.[2] Nauman was particularly interested in the work of Merce Cunningham and John Cage and 'the attitude involved in transforming normal activity into formal presentation'.[3] The young medium of video made it possible to stage, reproduce and observe simple actions such as walking, jumping and stamping, as exercised in Nauman's so-called 'studio films'. As Vilém Flusser argues in his phenomenology of gestures, video not only allows us to 'decipher' how we exist and communicate in the world but also makes 'legible' the small modifications that reveal society's continuing 'existential crisis'. The capturing of a expressive action on video 'already represents in part a change of a traditional gesture', illustrating the power the medium has over our actions as both performing and controlled subjects due to its 'dialogical structure'.[4]

Significantly, Flusser defines gesture as 'a movement of the body or of a tool connected to it for which there is no satisfying causal explanation'.[5] Gestures are not mere reactions but symbolically charged actions that convey meaning. In his early performances and photographs, Nauman purposely avoids productive actions and instead executes absurd actions (painting his balls black), slapstick performances (walking in an extremely bent position), repetitive exercises (jumping in a corner), games (bouncing a ball between floor and ceiling) and typological registers of facial expressions (grimaces) and verbal

PERFORMANCE RITUAL AND GESTURE IN NAUMAN

idioms (eating his words, feet of clay). They thus fulfil the 'definition' of gestures though, one might argue, some of them are so bizarre that they defy meaning. It is exactly this operation beyond the confines of reason that defines these 'frozen gestures' as authentic works of art, expressing something symbolically which cannot be captured by science or philosophy.[6] The misguided slapstick versions of prescribed behaviour with their exaggerated, non-directional movements, such as *Slow Angle Walk (Beckett Walk)* 1968, are a deliberately provocative travesty of the desired smooth operation of the masses acting in coordinated harmony. They are essentially futile and even wasteful actions which set the artist in direct opposition to a productive and utilitarian society.[7]

Nauman's claustrophobic performance settings and installations – fixed camera, empty spaces, corridors and the standard interview/interrogation set-up with table and chair – closely resemble the experimental conditions of behavioural studies, pursuing an objective observation of human and animal behaviour in neutral circumstances. The disembodied, all-seeing eye of the surveillance camera is employed to let us record and dissect these scenes without being physically present – like the detached scientist monitoring an experiment without interfering with its outcome. In Nauman's instructional pieces, clear indications are given to a subject to execute certain actions which might promote bodily and spatial awareness but also have a certain sadistic quality, forcing visitors to perform unnatural, uncomfortable or even ridiculous tasks ('Press as much of the front surface of your body (palms in or out, left or right cheek) against a wall as possible').[8] In setting up these situations in such a way that the subject (the exhibition visitor) is encouraged to execute a certain activity in the intended manner (for example in the corridor installations), Nauman takes on the role of the omnipotent researcher: 'the problem was for me to find a way to restrict the situation so that performance turned out to be the one I had in mind. In a way it was about control.'[9]

During the 1960s, psychology experienced a significant shift from explaining human behaviour as a result of external conditions to theories more focused on the individual and internal and, in particular, cognitive processes. Nauman's experimental exercises rehearse psychological theories from behaviourism's supposedly scientific assessment of human actions as responses to outside stimuli to Gestalt therapy's promotion of self-realisation through the unity of mind and body as a result of positive interaction with the environment and other individuals. This was the time of the notorious Milgram (1965) and Stanford Prison experiments (1971), which sensationally revealed uncomfortable truths about the power of authority and its disintegrating effect on supposedly stable moral positions.[10] These experiments seemed to confirm the theories of behaviourism, dominant from the early

Following page:
*Learned Helplessness in Rats
(Rock and Roll Drummer)* 1988

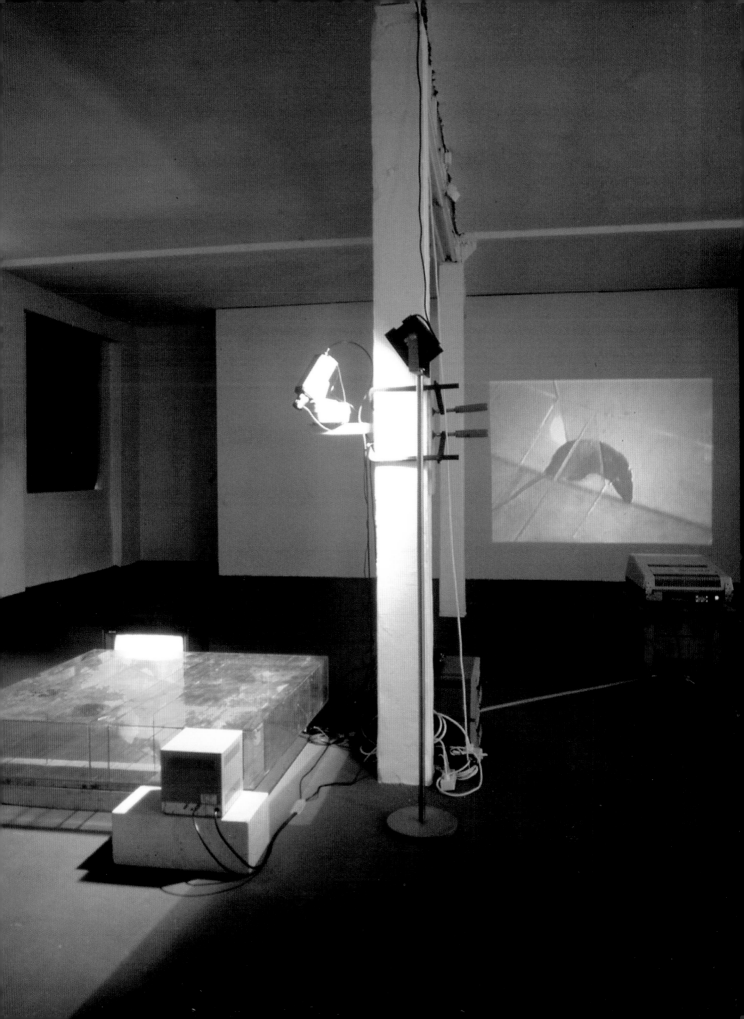

PERFORMANCE RITUAL AND GESTURE IN NAUMAN

decades of the century to the 1960s, which presented human (and animal) behaviour as the outcome of so-called 'operant conditioning' (a term coined by the proponent of 'radical behaviourism', B.F. Skinner). Actions were presented as responses to exterior impetus rather than to inner states (including feelings), which were generally dismissed as non-existent and irrelevant. Subjecting himself and others to closely controlled laboratory situations, Nauman plays with behaviourism's notion of the 'biological machine', executing pointless actions, often with robotic movements, without any display of independent motivation or discernible inner reflection.[11] Again and again Nauman returns to the issue of nature versus nature, conditioning versus self-determination and free will. Rats as the archetypal laboratory animals (all response, no consciousness) appear several times in Nauman's work, figuring most prominently in *Learned Helplessness in Rats (Rock and Roll Drummer)* 1988. The installation, with a video of a maze negotiated by rats accompanied by the incessant soundtrack of a drummer, exemplifies the notion of the human rat race, visualising a

Violent Incident 1986

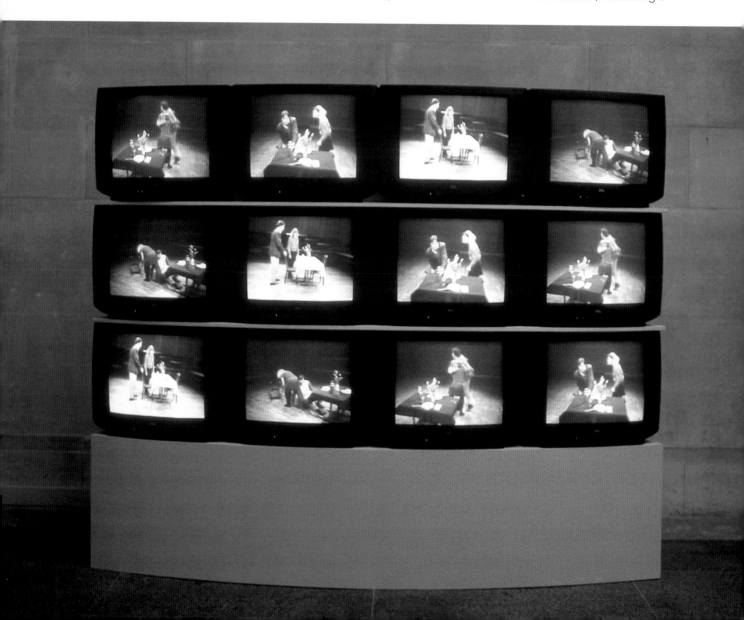

prominent psychological concept that describes the reaction (passivity, depression, resignation, etc.) to uncontrollable events.[12] Nauman reveals the absurdity of these experiments and the impossibility of objectively analysing, categorising and systematically indexing human behaviour. With the camera frequently turned by 90 or 180 degrees, with extreme close-ups of distorted faces or with the performing subject squeezed into a corner, supposedly scientific experiments turn into irrational and meaningless rituals revealing the proximity of assumed rationality and autistic withdrawal.

Cover, Julius Fast, *Body Language*
1971

Nauman's investigation of the perennial mind–body problem was also significantly informed by the reading of Frederick Perls' *Gestalt Therapy: Excitement and Growth in the Human Personality* (1951), which proposes a more benign view of human nature. In Gestalt therapy, creative activity is considered an essential instrument in achieving the desired state of 'experiential wholeness', in particular if fully employing the expressive capacities of the human body. One Gestalt therapist's description of preparing the body for creation reads like an instruction for Nauman's performance activities, in particular *Revolving Upside Down* 1969 or *Manipulating a Fluorescent Tube* 1969:

> Bent slightly at the knees, my legs begin to move in a walking motion. I feel energy building in my pelvis as I let the weight of my body rest fully on one leg, then the other. My hips rotate from one side to the other, allowing my body to experience its grace and flexibility. Now I am aware of my breathing: My belly sticks out as I inhale, my diaphragm descends into my abdomen. As the air enters my lungs, my chest expands and I feel like stretching: Arms move into the air sideways. My breathing is low and full.
>
> Mental imagery emerges from this physical liveliness. I begin to revolve in slow motion, imaging my body as a fluorescent sculpture turning in a dark, thick space. My arms break the darkness with thick, glowing lines, like the strong brush on Franz Kline's canvasses. My fingers brush the space with fine lines, five at a time, hanging horizontally in space like curved platinum wires.
>
> My body is a sculpture and in my imagery it makes impressions in space as it moves. Its mass moves through the air, fills in parts of the space, and moves on. My body is a breathing sculpture, drawing in the outside world and then exhaling it – continually disrupting and remaking space.[13]

PERFORMANCE
RITUAL
AND GESTURE
IN NAUMAN

While providing a useful tool for aligning physical and mental expression through movement in space, the bathos of the description does also anticipate the burgeoning self-help and pop psychology industry with its promise of easy success, popularity and satisfaction. Hugely popular self-help books such Julius Fast's *Body Language* (New York, 1970) provided simple clues for deciphering the behaviour of fellow humans but also suggested how to project a certain image. Based on the new (pseudo-)science of kinesics, these books promised to unravel the language of non-verbal communication. Much space was given to the successful attraction of sexual partners, making parts of Fast's book more of an instructional manual for sexual conquest based on primitive Darwinian survival strategies of the fittest. Central to kinesics was the attainment of consciousness (whether physical or mental) through movement. One of the countless therapies popular during the period was entitled 'JUAD', promising enlightenment through 'Jumping Up and Down'; JUAD, it was claimed, would not only relieve tensions but help you to become one with the world. (Jumping is, again, an activity featured, though with desperate undertones, in Nauman's early video *Bouncing in the Corner, No. 2: Upside Down* 1969). Other publications feature instructional photographs and diagrams directing readers how to control gestures and actions consciously in order to impress business partners, succeed at a job interview or communicate better with the opposite sex. *Violent Incident* 1986 depicts a multiple communication breakdown in the popular therapeutic format of the role play as a polite gesture quickly turns into brutal stabbing. The self-help genre follows the American myth of self-reliance, autonomy and the self-made man going back to at least Andrew Carnegie's bestseller *How to Win Friends and Influence People* (1936). It builds on the American assumption of happiness as a birthright, something which can be achieved through hard work, self-stylisation or just good luck – a journey supported by an endless number of churches, sects, new age communes, therapies, pharmaceutical products, exercise and diet fads.

Nauman emerged in a period when the barriers of codified social customs and strict behavioural codes seemed to be swept away by a wave of political upheaval, sexual revolution, women's emancipation and the civil rights movement. The loss of social and physical distance, and the new intimacy, were not only experienced as liberation but disturbed some social commentators, who perceived the close proximity of too many individuals as a source of tensions and social conflicts. Nauman has charted the fundamental shifts in expressions of human individuality and definitions of the self as well as the dynamic interaction of people in groups and social systems. In simple yet effective

films, videos, installations and Freudian word games he has revealed the painful absurdity of human existence and the desperate attempts to conceal this state of meaninglessness. However, within the absurd there always lies the seed for laughter as humanising factor and an anarchic force of relief.

1 'Only Connect: Bruce Nauman', in *The Hydrogen Jukebox: Selected Writings of Peter Schjeldahl, 1978–1990*, ed. Malin Wilson, Berkeley, Los Angeles and London, University of California Press, 1991, p. 105.

2 Michael Kirby, 'The Activity: A New Art Form', in *Art of Time: Essays on the Avant-Garde*, New York, Dutton, 1969, p. 155.

3 Bruce Nauman in Chris Dercon, 'Keep Taking It Apart: An Interview with Bruce Nauman', in *Bruce Nauman*, London, Hayward Gallery, 1998, p. 100.

4 Vilém Flusser, *Gesten: Versuch einer Phänomenologie*, Frankfurt am Main, Fischer, 1994, pp. 193, 187.

5 Ibid., p. 8.

6 Ibid., pp. 13–14.

7 It is the artist's privilege to be non-productive as he or she, 'strictly speaking, is the only "worker" left in a labouring society', and the only one who actually creates products of lasting value. Hannah Arendt, *The Human Condition*, Chicago and London, University of Chicago Press, 1998 (1958), pp. 127, 173.

8 'Body Pressure, 1974', in Janet Kraynak (ed.), *Please Pay Attention Please: Bruce Nauman's Words. Writings and Interviews*, Cambridge, MA, and London, MIT Press, 2003, p. 83.

9 Joan Simon, 'Breaking the Silence: An Interview with Bruce Nauman', in Robert C. Morgan (ed.), *Bruce Nauman*, Baltimore and London, Johns Hopkins University Press, 2002, p. 277 (first published in *Art in America*, vol. 76, no. 9, Sept. 1988, pp. 140–9, 203).

10 In the Milgram experiment, subjects were led to believe that they were administering increasingly severe electric shocks to strangers following the orders of a white-coated researcher. In the Stanford Prison experiment groups of students were divided into 'guards' and 'prisoners'. The experiment had to be stopped after five days after a revolt by the 'prisoners' and increasing aggression and incidents of abuse and humiliation of 'prisoners' on the part of the 'guards'.

11 B.F. Skinner, 'Skinner on Behaviourism', in Richard L. Gregory (ed.), *The Oxford Companion to the Mind*, New York and Oxford, Oxford University Press, 1987, p. 75.

12 The concept was first explored by Martin E.P. Seligman in the 1960s in experiments with rats. See Christopher Peterson, Steven F. Maier and Martin E.P. Seligman, *Learned Helplessness: A Theory for the Age of Personal Control*, New York and Oxford, Oxford University Press, 1993. Nauman first encountered the term in an article in *Scientific American*: E. Collins, 'Stressed Out: Learned Helplessness in Rats Sheds Light on Human Depression', vol. 257, no. 5, Nov. 1987, p. 30. Mice feature in *Mapping the Studio I (Fat Chance John Cage)* 2001, performing freely outside the labyrinth.

13 Joseph Zinker, *Creative Process in Gestalt Therapy*, New York, Brunner/Mazel, 1977, pp. 236–7.

Following pages:
Double Slap in the Face 1985

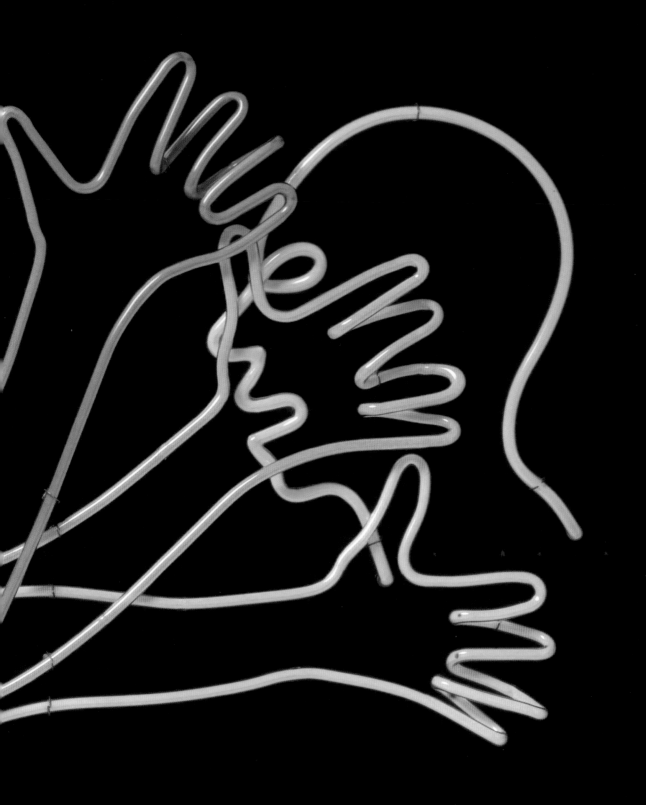

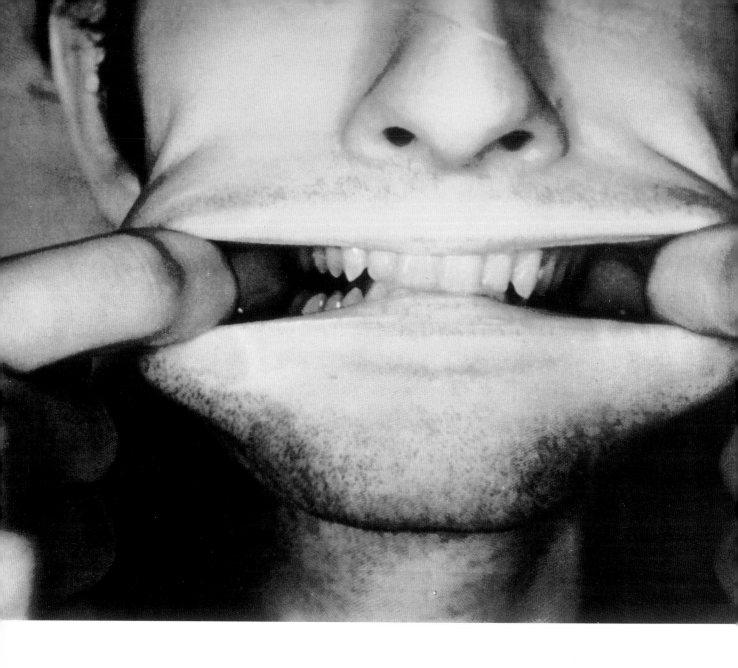

e 1970

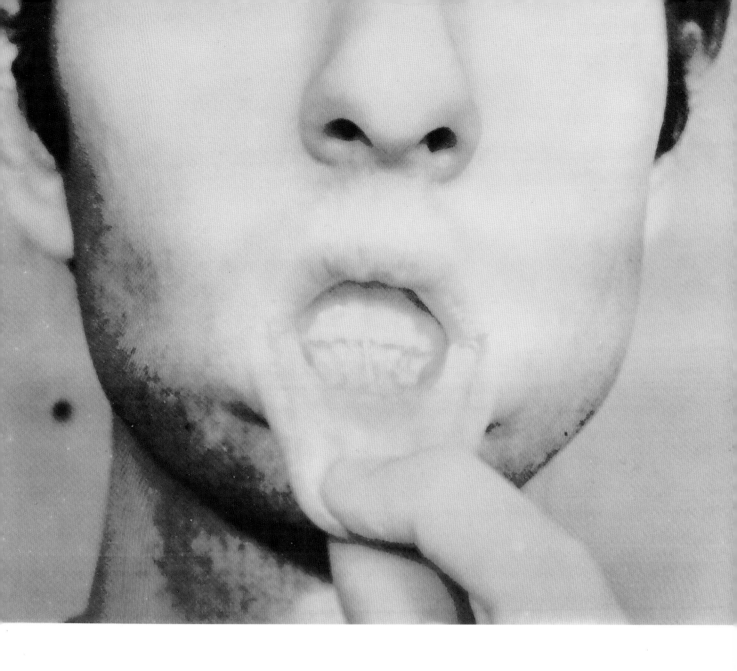

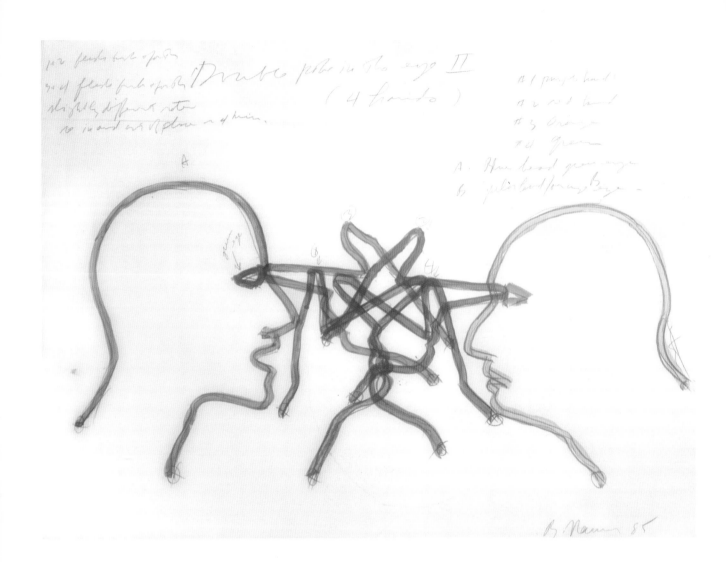

Double Poke in the Eye II 1985

Previous pages:
Double Slap in the Face 1985

Following page:
From *Frankfurt Portfolio* 1990

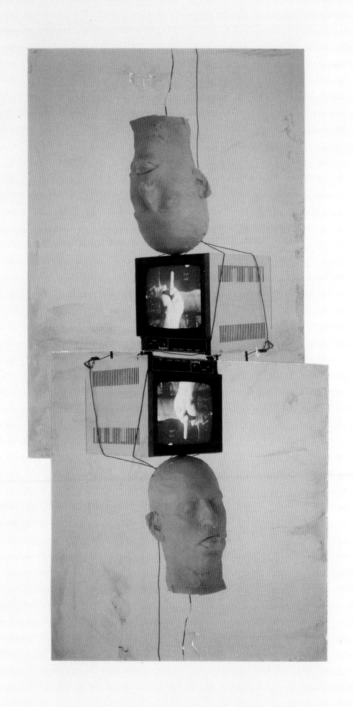

PNauman 25/35 90

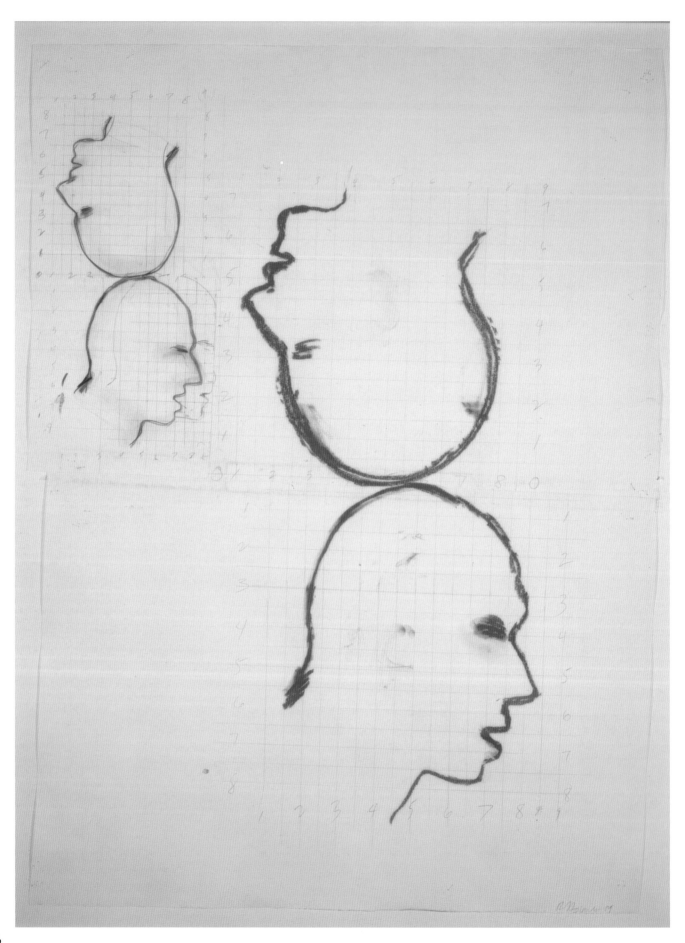

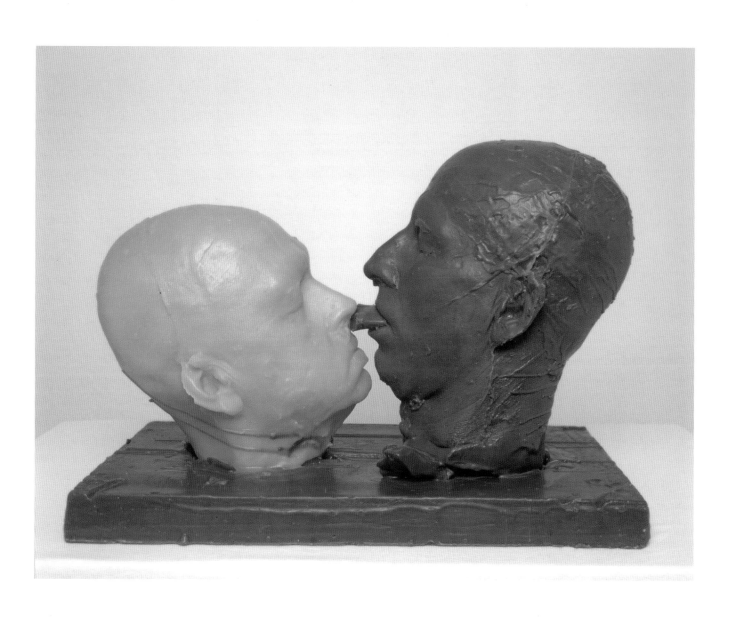

Rinde Head/Andrew Head
(Plug to Nose) on Wax Base 1989

Previous page:
Two Heads Double Size 1989

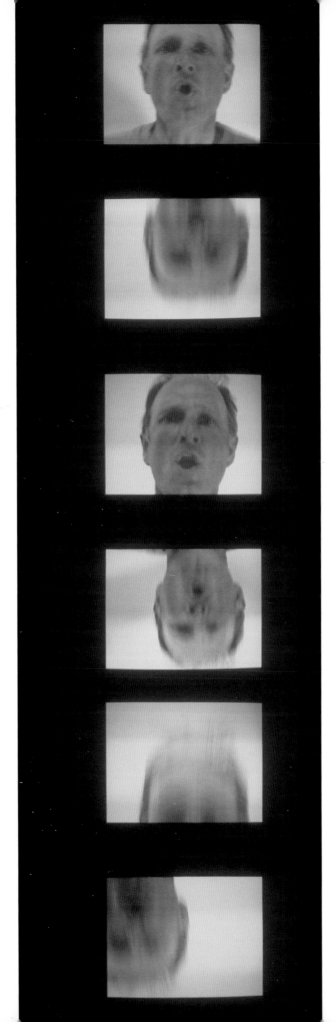

Work 1994

Jump 1994

Following pages:
Ten Heads Circle/Up and Down 1990

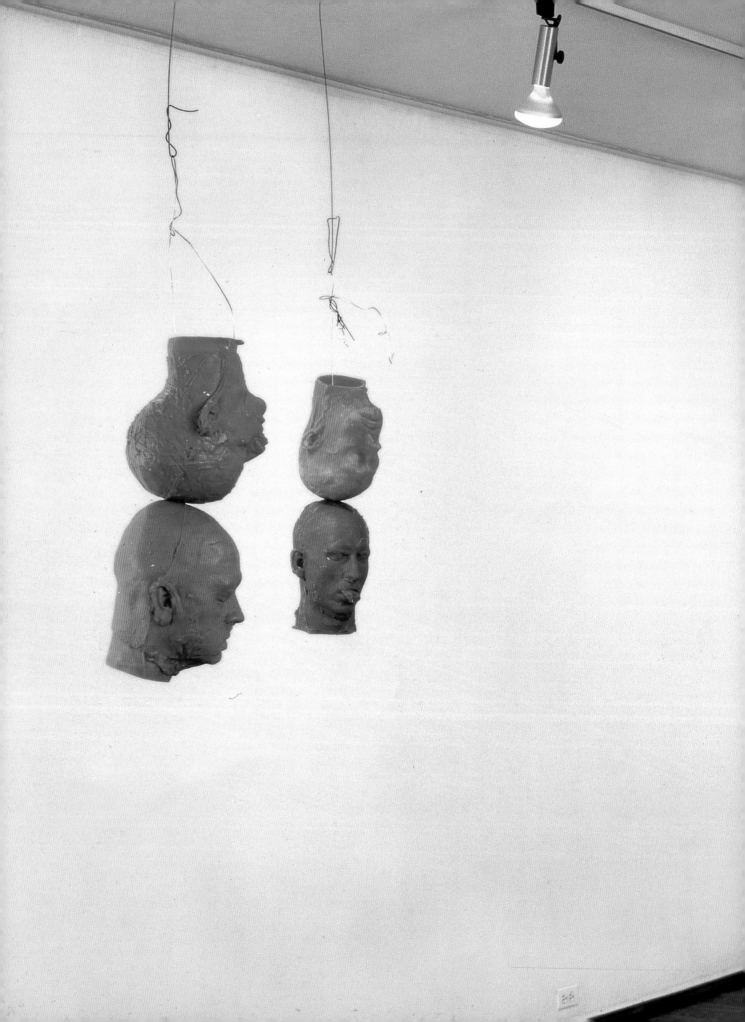

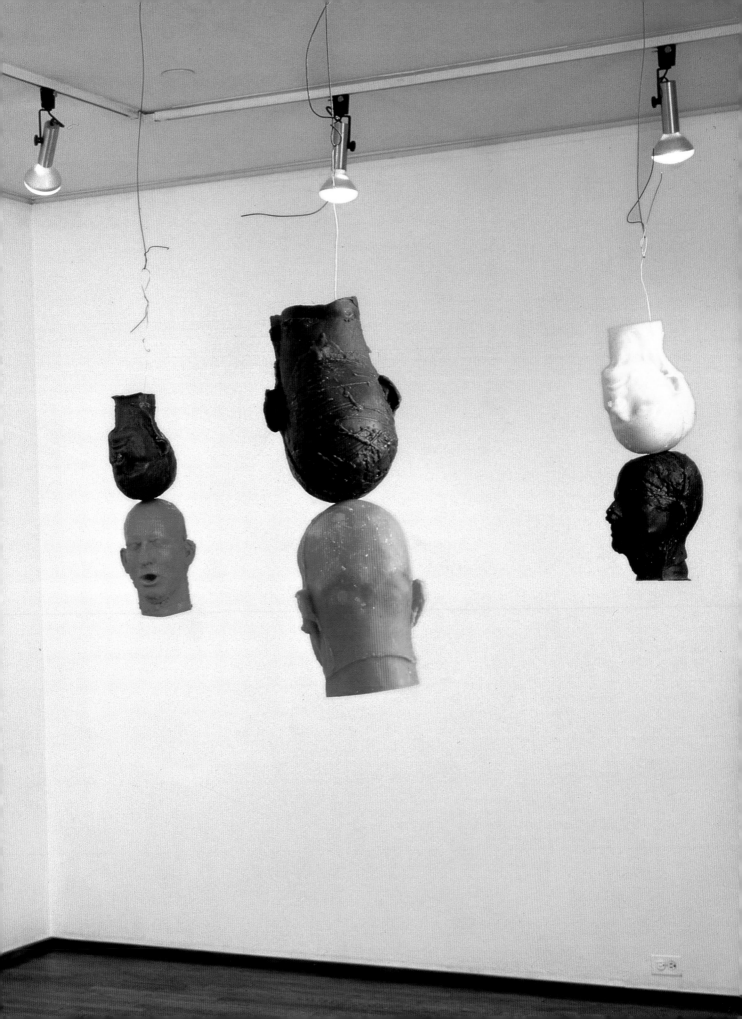

THE REVEALER OF MYSTIC TRUTHS

Lynne Cooke

Following page:
*Mapping the Studio
(Fat Chance John Cage)* I 2001

Mice invaded Bruce Nauman's studio in the summer of 1999. In response, he bought an inexpensive video camera and an infra-red lamp to track their nocturnal activity. Late that August, after establishing seven camera positions that mapped the perimeter of his studio, a prefabricated building on his ranch near Galisteo, New Mexico, he began recording. Continuing to shoot intermittently over the next three months, he finally amassed some 45 hours of footage, which he then edited and compressed to five hours and 45 minutes.

THE REVEALER OF MYSTIC TRUTHS

When initially presented in public, *Mapping the Studio (Fat Chance John Cage) I* 2001 took the form of an installation with seven projections whose grainy black and white footage eerily lit the vast gallery at Dia in New York. In the second version, *Mapping the Studio II*, Nauman introduced colour shifts, and flipped and flopped the imagery, further destabilising the uncanny scenario. In both, the arrangement of the projections mimics the original camera placements. Each projection is accompanied by its own stereo soundtrack, which consists mostly of ambient noises: trees rustling in a gale, a heavy rainstorm, the occasional barking of a dog, a train passing in the distance, a cat's plaintive miaow.

These recordings reveal evidence of daily activity in the studio, as well as showing stuff that has accumulated over time. Depending on the work carried out during the day, objects may shift around or even disappear: a ladder, for example, is removed midway through the cycle, and the screen door is shut, presumably in response to the weather cooling. Near the centre of the room, a couple of chairs, stacks of video cassettes and several monitors create a kind of oasis – the site for reviewing the previous night's footage. Occasionally a blurred figure can be glimpsed crossing the camera's sight line, as the artist exits the room after inserting a new cassette into the camera. And stray moths and other insects, interrupting the otherwise static mise-en-scène, leave brief luminous traces. The most compelling actors, however, are Toonsis the tailless cat, more bored than excited by the invasion of potential prey, and the effervescent mice that have appropriated the studio as their stage.

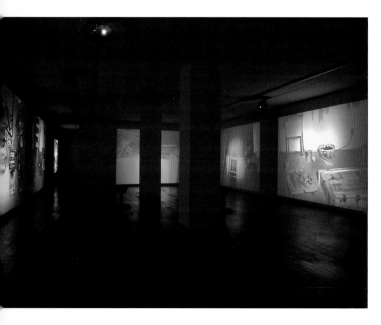

*Mapping the Studio
(Fat Chance John Cage) I 2001*

While *Mapping the Studio I* and *II* continue a practice Nauman established at the beginning of his career of treating his studio as a laboratory for performance work made explicitly for the camera, *Setting a Good Corner* 1999, made shortly after, is somewhat unusual in being situated outdoors, on his ranch. Documenting his other life, as a breeder of horses, it records in real time and in straightforward, pragmatic fashion an everyday activity. A fixed camera was set up so that it focused directly on the site where the artist/rancher intended to construct a corner, a junction of the two fences that would later be built out from this point. Lasting an hour, the length of a tape, this work documents his actions – excavating holes, setting posts, straining tension wires, inserting stays – together with certain fortuitous events, including the arrival

of his wife with their dogs. The detached matter-of-factness of the presentation serves paradoxically to reinforce a seemingly irresolvable ambiguity at the core of the piece: the question of how it should be read – even by a committed viewer who sits through the full sixty minutes to the closing frames when, instead of credits, comments from Nauman's veteran neighbours on the (relative) novice's technique scroll down the screen.

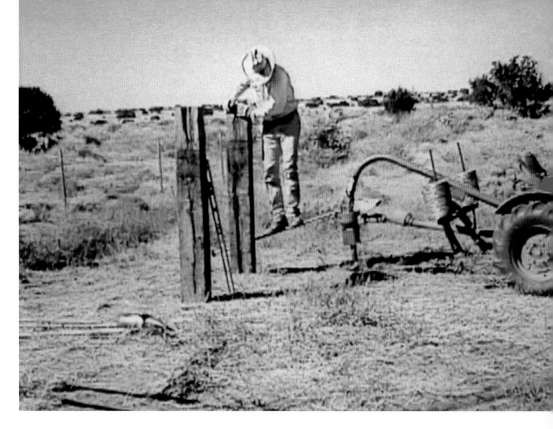

Setting a Good Corner
(Allegory and Metaphor) 1999

Mapping the Studio and *Setting a Good Corner* reprise key themes and preoccupations that Nauman has mined and honed over a career spanning some forty years. *Fishing for Asian Carp* 1966, one of his first ventures with film, lasts just under three minutes, the length of time it took the protagonist (William T. Allen) to capture his quarry.[1] Like several other task-oriented films Nauman shot about this time, *Fishing for Asian Carp* reflects the strong impression made on him as a student by an industrial training film depicting an elevator in operation, its doors mechanically and repetitively opening and closing. In the late sixties, he began his exploration of the practice of art-making per se and, hence, of the role of the artist. Certain of these performances put under duress his own body, or those of paid performers or of spectators; others took a more psychological orientation: compare the physically exhausting *Slow Angle Walk (Beckett Walk)* 1968 with *Elke Allowing the Floor to Rise Up Over Her, Face Up* and *Tony Sinking Into the Floor, Face Up and Face Down* (both 1973), which involve exacting mental exercises in their protagonists try, by concentrating intensely, to suffuse themselves into the architecture of the room. Sometimes these works were orchestrated for the camera in the studio, and so became single-monitor video pieces; sometimes they were choreographed for a gallery or museum situation.

With *Performance Corridor* 1969 Nauman transformed a prop that had initially been built for a monitor piece into an autonomous work. Moored to the wall of the gallery,

THE REVEALER
OF MYSTIC
TRUTHS

*Left or Standing,
Standing or Left Standing* 1971

the long, narrow plywood structure teases the visitor to venture into its claustrophobic recesses, where any actions she or he undertakes will have been predetermined by the artist. A seminal piece, it soon spawned numerous progeny. Some, such as *Corridor Installation (Nick Wilder Installation)* 1970, incorporate surveillance cameras and closed-circuit video systems that function like electronic mirrors. Both these virtual mirrors and the real mirrors the artist used elsewhere allowed spectators to see into unexpected spaces or from unanticipated angles. In denying physical access into what can only be glimpsed they introduce a signature sense of frustration, and dislocation. By contrast, *Left or Standing, Standing or Left Standing* 1971 saturates the space with a garish luminosity that taxes the viewer's perception before producing disturbing purplish after-images. A laconic text placed on each monitor at its two entrances defines the sources of the unsettling fear that its eerie physical counterpart occasions. 'Perhaps the space was insufficient,' Nauman conceded. 'In a way it's a poem that stands by itself, next to the space, without describing it. The writing is about language; it includes a kind of anxiety that the space seemed to generate.'[2]

Subsequently Nauman adopted less overtly controlling means and confrontational situations when challenging his audience's psychic and physical equilibrium.[3] In *Cones Cojones* 1973–75, for example, he used masking tape to redraw the topography of the gallery. The concentric arcs limned on the floor are meant to represent cross-sections of giant cones that begin at the centre of the earth and project into the universe, immersing the viewer at their disorienting core. A disjunctive text of fragmentary typewritten phrases

pasted on two large sheets of paper accompanies this floor piece. Syllogisms riddled with word-plays, snippets of stream-of-consciousness ramblings, and quasi-scientific statements are randomly juxtaposed 'like a bunch of fortune cookies lying on a dinner table'.[4] Slipping seamlessly from 'Let's talk about control' to 'We are talking about control', an anonymous interlocutor finally commands, 'Placate my art.' Whereas in his earlier works Nauman defined the role of the artist as a seer or visionary – the revealer of 'mystic truths' – in his more recent works he has offered a more sinister paradigm: authoritarian, manipulative, implacable.

Typically low-key and low-budget in their form and their fabrication, *Mapping the Studio* and at recent related video works imply that the struggle to conceive a work of art is more likely to involve hours of tedious repetitive activity, or bleak periods of seemingly fruitless inactivity, than macho manipulations of recalcitrant material, or virtuoso displays of craftsmanship, or transcendent insights. But, irrespective of whether externally

Cones Cojones 1973-75

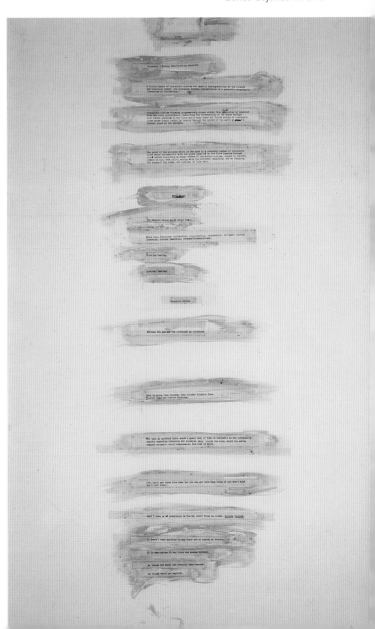

imposed or (more frequently these days) self-determined, Nauman's discipline of limited means produces works that are disarmingly nonchalant, unassumingly rough-edged, even blackly humorous as they relentlessly pillory received notions of inspiration and creativity, and hence of the role and image of the artist. At once impassioned and deeply impersonal, his practice approaches more closely the activities of a protagonist in a Samuel Beckett play than it does the standard Hollywood movie treatment of the inspired genius, be it Picasso or Pollock.

This combination of an elusive content and assertive presentation brings to mind Nauman's telling averral made in 1971: 'When you display a piece of art, normally you add something to the environment. You give extra information. I thought why not remove some of the information.'[5] This strategy of aphoristic parsimony – of withholding as a means of communication, of refusal as a mode of articulation – manifests itself again and again. Its multifarious origins include the never-forgotten advice of one of his instructors in Davis, California, William Wiley, as to the importance of 'seeing with a dumb eye'. But equally inspirational for

this relentless probing of models for artistic practice have been Wittgenstein's rigorous investigatory procedures in his *Tractatus Logico-Philosophicus* and Beckett's austerely reductive short texts for theatre. As Nauman sought to impart form, structure, significance, and a moral undergirding to the daily activities of an artist, whether in his studio or later as a rancher at work on his land, both these precedents proved exemplary.

In his mordant yet affectionate studies of the figure of the cowboy in North American culture, Larry McMurtry traces the gradual evolution of this shape-shifting protagonist from the epic heroic to the ironic, the sentimental, and, recently, back to the archetypal. Commenting on the inevitable gulf between representation and actuality, McMurtry notes that the dominant skill of the cowboy (unlike that of the gunfighter) was horsemanship (not marksmanship); yet the working cowboy has never been important to the Western movie's characterisation.[6] Recognising, as does McMurtry, that it is the symbolic frontiersman who has long been absorbed into the national bloodstream, Nauman as artist/rancher investigates his counterparts in his visual praxis by interweaving fact and fiction, as seen in a comparison of *Setting a Good Corner* and *Green Horses* 1998. The myth of the West, filtered primarily through the figure of the cowboy beloved of literature and music as well as film, infuses these works with a disarming irony. Deadpan and straight-shot, Nauman begins with the actualities, the quiddities of the literal, phenomenal world, whereas artists of a later generation, such as Rodney Graham, start from issues of representation. Yet Nauman's laconic surface is as much a subterfuge as Graham's self-mocking romanticism, as seen in a comparison of *Green Horses* 1998 and *How I Became a Ramblin' Man* 1999. The maxim Nauman coined long ago still holds: 'The true artist helps the world by revealing mystic truths.'[7] Its ambiguity is inescapable: revelation is as likely to imply exposure as disclosure.

1 For a detailed study of this and all works in Nauman's oeuvre, see the catalogue raisonné *Bruce Nauman*, New York, Distributed Art Publishers, in association with Walker Art Center, Minneapolis, 1994.

2 Nauman quoted in Coosje van Bruggen, *Bruce Nauman*, New York, Rizzoli, 1988, p. 193.

3 'I mistrust audience participation,' Nauman stated in 1970. 'That's why I try to make these works as limiting as possible.' 'Bruce Nauman Interviewed by Willoughby Sharp', *Arts Magazine*, 44, no. 5, March 1970, p. 23. The spectator or the hired performer therefore does 'something similar to what I would do'; 'Bruce Nauman Interviewed by Willoughby Sharp', *Avalanche*, no. 2, Winter 1971, p. 27.

4 Nauman quoted in van Bruggen, *Bruce Nauman*, p. 195.

5 Nauman quoted in Jane Livingston, 'Bruce Nauman', in *Bruce Nauman: Work from 1965 to 1972*, Los Angeles, Los Angeles County Museum of Art, 1972, p. 24.

6 Larry McMurtry, *Walter Benjamin at the Dairy Queen: Reflections at Sixty and Beyond*, New York, Simon and Schuster, 1999, p. 186. See also McMurtry's landmark early study, *In a Narrow Grave: Essays on Texas*, Austin, Texas, Encino Press, 1968.

7 This is the text of a neon work executed in 1967, *The True Artist Helps the World by Revealing Mystic Truths (Window and Wall Sign)*.

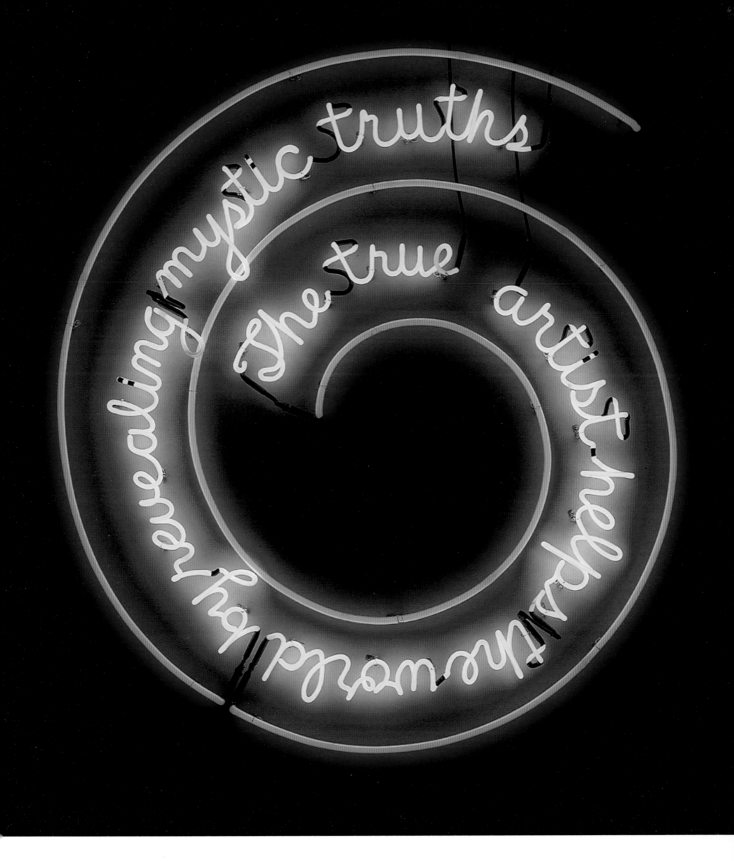

*The True Artist Helps the World by Revealing
Mystic Truths (Window and Wall Sign)* 1967

LIST OF EXHIBITED WORKS

Height precedes width precedes depth

Eleven Color Photographs 1966/7-70
Portfolio with eleven colour photographs
Dimensions vary slightly, each approx. 50.2 x 58.4
cm (19.7 x 22.9 in.)
Bound to Fail 1966

*Coffee Spilled Because
the Cup Was Too Hot* 1967

*Coffee Thrown Away Because
It Was Too Cold* 1967

Drill Team 1966

Eating My Words 1966

Feet of Clay 1966

Finger Touch No. 1 1966

Finger Touch with Mirrors 1966

Self-Portrait as a Fountain 1966

Untitled (Potholder) 1967

Waxing Hot 1967
Froehlich Collection, Stuttgart

*Dance or Exercise on the Perimeter of a Square
(Square Dance)* 1967-8
Projection, film transferred to DVD,
black and white, sound
Approx. 10 minutes
Electronic Arts Intermix, New York

First Poem Piece 1968
Steel
2 x 150 x 150 cm (0.7 x 59 x 59 in.)
Kröller-Müller Museum, Otterlo, The Netherlands,
formerly in the Visser collection

Get Out of My Mind, Get Out of This Room 1968
Audio recording played in a room, 6 minutes looped
Collection Jack and Nell Wendler, London

*Playing a Note on the Violin While I Walk Around
the Studio* 1968
Projection, film transferred to DVD, black and
white, sound
Approx. 10 minutes
Electronic Arts Intermix, New York

RawWar 1968
Pencil, coloured pencil and watercolour on paper
75.5 x 55.8 cm (29.7 x 21.9 in.)
Froehlich Collection, Stuttgart

Slow Angle Walk (Beckett Walk) 1968
Video, black and white, sound
Approx. 60 minutes repeated continuously
Electronic Arts Intermix, New York

Stamping in the Studio 1968
Video, black and white, sound
Approx. 60 minutes repeated continuously
Electronic Arts Intermix, New York

Study for First Poem Piece 1968
Ink and pencil on paper
36.5 x 51 cm (14.3 x 20 in.)
Kröller-Müller Museum, Otterlo, The Netherlands,
formerly in the Visser collection

Study for First Poem Piece 1968
Pencil on paper
50 x 65 cm (19.6 x 25.5 in.)
Kröller-Müller Museum, Otterlo, The Netherlands,
formerly lent by the Visser collection

Suite Substitute 1968
Neon tubing with clear glass tubing
suspension frame
13.2 x 127 x 12.7 cm (5.1 x 50 x 5 in.)
Froehlich Collection, Stuttgart

Walk with Contrapposto 1968
Video, black and white, sound
Approx. 60 minutes repeated continuously
Electronic Arts Intermix, New York

Lip Sync 1969
Video, black and white, sound
Approx. 60 minutes repeated continuously
Electronic Arts Intermix, New York

a - e 1970
From *Studies for Holograms*
Five screenprints on paper
Dimensions vary slightly,
each approx. 51 x 66 cm (20 x 25.9 in.)
Tate. Purchased 1994

Corridor Installation (Nick Wilder Installation) 1970
Wallboard, closed-circuit television cameras,
black and white monitors, video, video player
Approx. 335.3 x 1219.2 x 626 cm
(133 x 480 x 246.4 in.)
Friedrich Christian Flick Collection

Henry Moore, Bound to Fail 1967 cast 1970
Cast iron
64.8 x 61 x 6.4 cm (25.5 x 24 x 2.5 in.)
Froehlich Collection, Stuttgart

Raw War 1970
Neon tubing with clear glass suspension frame
16.5 x 43.5 x 6.4 cm (6.5 x 17.1 x 2.5 in.)
Sonnabend Collection

Corridor with Mirror and White Lights 1971
Wood, glass and fluorescent lights
304.8 x 17.8 x 1219.2 cm
(120 x 7 x 480 in.)
Tate. Purchased 1973

Raw-War 1971
Lithograph on paper
56.7 x 71.7 cm (22.3 x 28.2 in.)
Tate. Purchased 1992

La Brea/Art Tips/Rat Spit/Tar Pits 1972
Neon tubing with glass tubing suspension frame
61.9 x 58.4 x 5.1 cm (24.4 x 23 x 2 in.)
Anthony d'Offay, London

Run from Fear, Fun from Rear 1972
Neon tubing with clear glass
tubing suspension frame
Two parts: 19 x 116.6 x 2.8 and 10.8 x 113 x 2.8 cm
(7.4 x 45.9 x 1.1 and 4.2 x 44.4. x 1.1 in.)
Froehlich Collection, Stuttgart

Drawing for Nick Wilder Installation 1973
Pencil on paper
73 x 58.5 cm (28.7 x 23 in.)
Kröller-Müller Museum,
Otterlo, The Netherlands

*Elke Allowing the Floor to Rise Up
Over Her, Face Up* 1973
Video, colour, sound
40 minutes repeated continuously
Electronic Arts Intermix, New York

M Ampere 1973
Lithograph on paper
76.2 x 112.5 cm (30 x 44.2 in.)
Tate. Purchased 1990

*Tony Sinking into the Floor, Face Up
and Face Down* 1973
Video, colour, sound
60 minutes repeated continuously
Electronic Arts Intermix, New York

Body Pressure 1974
Wall-mounted poster with printed text
Wall dimensions variable, poster dimensions
64 x 42 cm (25.3 x 16.5 in.)
Friedrich Christian Flick Collection

Double Steel Cage Piece 1974
Steel
Outer cage 216 x 520 x 392 cm
(85 x 204.7 x 154.3 in.)
Inner cage 185 x 457 x 330 cm
(72.8 x 179.9 x 129.9 in.)
Rotterdam, Museum Boijmans Van Beuningen

Double Face 1981
Lithograph on paper
66 x 91.4 cm (25.9 x 35.9 in.)
Tate. Presented by Karsten Schubert 2001

No (Black State) 1981
Lithograph on paper
69.8 x 103.8 cm (27.4 x 40.8 in.)
Tate. Purchased 1983

*Three Dead End Adjacent Tunnels,
Not Connected* 1981
Cast iron
63 x 286 x 247.6 cm (24.8 x 112.5 x 97.5 in.)
Tate. Presented by the American Fund
for the Tate Gallery 1992

American Violence 1983
Pencil and tape on paper
76.2 x 99 cm (30 x 38.9 in.)
Froehlich Collection, Stuttgart

Human Nature/Knows Doesn't Know 1983/6
Neon tubing with clear glass tubing suspension frame
230 x 230 x 35.5 cm (90.5 x 90.5 x 13.9 in.)
Froehlich Collection, Stuttgart

Double Poke in the Eye II 1985
Pencil and watercolour on paper
57 x 78 cm (22.4 x 30.7 in.)
Froehlich Collection, Stuttgart

Double Slap in the Face 1985
Neon tubing with clear glass tubing
suspension frame
76 x 127 x 13.5 cm (29.9 x 50 x 5.3 in.)
Froehlich Collection, Stuttgart

Good Boy Bad Boy 1985
Video, two monitors, colour, sound
Dimensions variable
Tate. Purchased 1994

Violent Incident 1986
Video, twelve monitors, colour, sound
200 x 250 x 90 cm (78.7 x 98.4 x 35.4 in.)
Tate. Purchased 1993

*Rinde Head/Andrew Head
(Plug to Nose) on Wax Base* 1989
Wax
32.9 x 47 x 29 cm (12.9 x 18.5 x 11.4 in.)
Froehlich Collection, Stuttgart

Two Heads Double Size 1989
Pastel, pencil and tape on paper
165 x 129.5 cm (64.9 x 50.9 in.)
Froehlich Collection, Stuttgart

Untitled (Three Large Animals) 1989
Aluminium and wire
120 x 300 x 300 cm (47.2 x 118.1 x 118.1 in.)
Tate. Presented by The Froehlich Collection,
Stuttgart 2000

Untitled (Two Wolves, Two Deer) 1989
Foam, wax and wire
142.2 x 375.9 x 368.3 cm
(55.9 x 147.9 x 145 in.)
Froehlich Collection, Stuttgart

Frankfurt Portfolio 1990
Four prints on paper
Dimensions vary slightly,
each approx. 48.5 x 32.5 cm (19 x 12.7 in.)
Tate. Purchased 1999

Shit in Your Hat – Head on a Chair 1990
Video projection, chair, wax head,
screen and steel cable
Dimensions variable
Collection of Contemporary Art Fundació
'la Caixa', Barcelona

Ten Heads Circle/Up and Down 1990
Wax and wire
Diameter 243.8 cm (96 in.). Heads suspended
180.3 cm (71 in.) above the floor
The Eli and Edythe L. Broad Collection

Jump 1994
Video, two monitors, colour and sound
Private Collection, Spain, courtesy of
Donald Young Gallery, Chicago

Make Me Think Me 1994
Graphite and tape on paper
142 x 97.2 cm (55.9 x 38.2 in.)
Froehlich Collection, Stuttgart

Untitled (from Fingers and Holes) 1994
Lithograph on paper
76.1 x 101.6 cm (29.9 x 40 in.)
Tate. Purchased 1996

Untitled (from Fingers and Holes) 1994
Lithograph on paper
81.8 x 82 cm (32.2 x 32.2 in.)
Tate. Purchased 1996

Work 1994
Video, two monitors, colour, sound
Froehlich Collection, Stuttgart

World Peace (Received) 1996
Video, five monitors, colour, sound,
five trolleys and stool
320 cm (125.9 in.) diameter
Saint Louis Art Museum, Museum Shop Fund and
funds given by Mr. and Mrs. Donald L. Bryant Jr.,
the Henry L. and Natalie Edison Freund Charitable
Trust, the Siteman Contemporary Art Fund, the
Eliza McMillan Trust, Anabeth Calkins and John
Weil, the Contemporary Art Society, Mrs. Joan
B. Bailey, the Honorable and Mrs. Thomas F.
Eagleton, Mrs. Gail K. Fischmann, Mrs. Eleanor J.
Moore, Mr. and Mrs. E. R. Thomas Jr., Gary Wolff,
Mr. and Mrs. David Mesker, Mr. and Mrs. Kenneth
S. Kranzberg, Mrs. Janet M. Weakley, and the
Greenberg Van Doren Gallery

Life Fly Lifes Flies 1997
Etching on paper
93.9 x 68.6 cm (36.9 x 27 in.)
Tate. Lent by the American Fund
for the Tate Gallery
courtesy of Jean-Christophe Castelli
in memory of Leo Castelli 2001

All Thumbs Holding Hands 1998
Lithograph and collage on paper
76.2 x 56.3 cm (30 x 22.1 in.)
Tate. Purchased 1999

Setting a Good Corner (Allegory and Metaphor)
1999
DVD projection, colour and sound
59 minutes 30 seconds
Sperone Westwater Gallery, New York

Three Heads Fountain (Juliet, Andrew, Rinde) 2005
Epoxy resin and fiberglass
25.3 x 53.3 x 53.3 cm (9.9 x 20.9 x 20.9 in.)
Basin approximately 20.3 x 365.7 x 365.7 cm
(7.9 x 143.7 x 143.7 in.)
Private Collection, Spain, courtesy
of Donald Young Gallery, Chicago

The Trustees of Tate, the Director of Tate and the Director of Tate Liverpool would like to thank
the following for their generous support during 2006:

Sponsors and Donors
Austrian Cultural Forum London
BT
Catherine and Franck Petitgas
DLA Piper Rudnick Gray Cary
The Henry Moore Foundation
Liverpool Culture Company Limited
Liverpool John Moores University
Manchester Airport Plc.
Tate Liverpool Members
Tate Members

Corporate Partners
David M Robinson Fine Jewellery & Watches
DLA Piper Rudnick Gray Cary
DWF
Ethel Austin Property Group
Hill Dickinson
HSBC Bank Plc.
Laureate Online Education
Liverpool Hope University
Liverpool John Moores University
Mason Owen & Partners
Toyota
The University of Liverpool
Unilever UK

Corporate Members
Andrew Collinge
Bank of Scotland Corporate
Barlows Plc.
Beetham Organization Limited
Alder Hey Imagine Appeal, supported by Berrington Fund Management
Bruntwood
Building Design Partnership
Deloitte
Grant Thornton
Grosvenor
KPMG
Neptune Developments Limited
Plexus Cotton Ltd.
Racquet Club
Royal Bank of Scotland
Silverbeck Rymer
The Mersey Television Company Ltd.
Tilney Investment Management